MR CLASSIC

ミスター・クラシック イエスタデイ&トゥモロー

YESTERDAY & TOMORROW

Text & Photographs by Jeremy Hackett
Translation & Production by Yoshimi Hasegawa

本文・撮影：ジェレミー・ハケット
翻訳・プロデュース：長谷川喜美

BANRAISHA

JEREMY HACKETT

Published by Banraisha Co., Ltd.
Kudan Central Bldg. 803, Iidabashi 2-1-4, Chiyoda-ku, Tokyo, Japan 102-0072
http://www.banraisha.co.jp/
E-Mail letters@banraisha.co.jp

MR. CLASSIC : YESTERDAY & TOMORROW
Copyright © 2016 by Jeremy Hackett and Yoshimi Hasegawa
All rights reserved. Printed in Japan.

ISBN978-4-908493-09-6

Contents

- 4 はじめに　ニック・フォークス
 Foreword by Nick Foulkes

- 9 **Chapter 1**
 ミスター・クラシックになる方法　Being Mr. Classic

- 41 **Chapter 2**
 イエスタデイ＆トゥモロー　Yesterday & Tomorrow

- 42 私のお気に入り　My Favourite Find
- 44 靴　Shoes
- 52 時計　Watches
- 62 "フォックス・ブラザーズ"とフランネル　Fox Brothers & Flannel
- 68 ある男のダイアリー　Diary of a somebody
- 86 ドッグ・デイ・アフタヌーン　Dog Day Afternoon
- 94 パートナーシップ　Partnerships
- 104 グッドウッド・リバイバル　Goodwood Revival
- 114 家族の休日　Family Holidays
- 118 インド：私を魅了する国　India: A Country That has Inspired Me
- 122 旅の土産　Souvenir from the trip
- 124 パッキング　Packing
- 128 日本：京都、福岡、神戸、東京　Japan: Kyoto, Fukuoka, Kobe and Tokyo
- 132 イエスタデイ＆トゥモロー フォトエキシビジョン
 Yesterday & Tomorrow Photo Exhibition

- 155 **Chapter 3**
 紳士になる方法　Being a Gentleman

- 172 おわりに　長谷川喜美
 Afterword by Yoshimi Hasegawa

はじめに

ジェレミー・ハケットとディナーをしたときのことだ。彼はカフをたくしあげ、カフリンクスを見せた。
彼が服装を自慢したり、見せたりすることは滅多にないので興味を引いた。
このモチーフが何かわかるかと彼は訊ねた。スターリングシルバーの小さな長方形に2つの穴があり、
Pの形に切り取られている。豪華なドールハウスのために作られた小人用のボトルオープナーのようだった。

そのデザインには見覚えがあった。旧知の友人に会ったような懐かしさを覚えた。
パーソンズ・グリーンにあった最初のハケット・ショップのファサードだ。奇妙な背の低い白いビルディング、
「貧乏人のチェルシー」にあった古着屋というよりは、F・スコット・フィッツジェラルド時代の
コート・ダジュールに建っている、アール・デコ・スタイルのヴィラにある翼(よく)のように思えた。

1983年のことだ。

それから現在まで多くのものが変わった。

最近はセカンドハンド・クローズ（古着）、正確にいえばヴィンテージ・クローズを語る者はいない。
すべては変わってしまい、パーソンズ・グリーンで貧しい男を最後に見たのがいつかも覚えていない。
ハケットはインターナショナルなリテールスケープ(注1)の中で、世界的に有名なブランドの地位を獲得している。
ジェレミーは彼の名前を彼の店と分かち合ったばかりではない。彼は私たち全員とその名を分かち合っている。
いまやハケットは英語の単語、それもふたつの音節を持つ形容詞となった。わずかにエキセントリックで、
辛辣なユーモアがあり、非の打ち所のないマナーに基づいた、謙虚でいて完全なる世界、
必要不可欠な英国的装備としてのブリティッシュ・キット、それがジェレミー・ハケットの世界だ。

1983年以来ほとんど変わっていない唯一のものといえば彼自身である。
ちょっとはにかんだような、変わらぬ笑みを浮かべる。柔らかな調子で話す。彼の物腰は極めて穏やかなので、
そのときは気付かないが、後から、あれは愛情をこめてからかわれていたのだと気が付くような
ユーモラスなマナーも同じだ。彼はイングランド西部で織られたグレーフランネル(注2)、
スローピング・ショルダーの同じスーツを着ている。

まるでソヴィエトのスローガンのような駄洒落や言葉遊びを同じように愛している。
「フォーマル・ドレス（正装）はファンシー・ドレス（着飾った服装）ではない」。
最も知られているフレーズのひとつだ。

もし彼をよく知らない人が見たら、名声が彼を変えることはなかったと思うに違いない。
彼は高尚なその道の権威というより、ある種、典型的なイギリス人のように見える。
だが、ジェレミーの人生における夢といえばヨットや自家用ジェットやペントハウスを持つことではない。
一分の隙もない完璧なテーラードのスーツを半ダース、ワードローブに持つこと。
その中には犬の散歩用にコーデュロイのパンツと肘あてのついたツイードジャケットもあることだろう。
重要、かつ怠惰なアクティビティとして、ロンドンの家の庭にあるデッキチェアに座り、
彼の好きな葉巻、ホヨー・ドゥ・モントレー・エピキュール No.2 を嗜むこと、それが彼の夢である。

彼を知る人にとってジェレミーは「歩くメンズウェアの百科事典」以上の存在である。
ウィットに富んだライターであり、その内容は時計や車など多岐にわたる。
独自の美学で興味深い色彩感覚を持った才能のあるフォトグラファーでもある。スケートボーディング、
古ぼけたネオンサイン、半分だけ吸われた葉巻など、他の人が見たら凡庸に見えるものでも、
彼にはそれぞれの魅力や個性、ユニークな類いの美を見抜く目があるからだ。

この本はメンズウェアの巨人の見解をまとめたものにとどまらない。
外見同様に内面のエレガンスと共に生きる、彼の人生への個人的な讃歌なのだ。
願わくば、優しく誠実で一緒にいる人々を楽しくさせる男、幸運にも私が友人と呼ぶことのできるこの男を、
この本を通して多くの読者が知ってくれることを望んでいる。

ライフスタイル・コメンテイター
ニック・フォルクス

（注1）ランドスケープなどの言葉から派生したニック・フォークス流の造語。リテイラーの世界の意。
（注2）イングランド西部、サマーセットに本社を持つミル、創業1772年〝フォックス・ブラザーズ〟のフランネルを指している。

Foreword

We were having dinner when Jeremy Hackett shot his cuff, and showed me a pair of cufflinks. It is uncharacteristic of him to draw attention to his dress so I was intrigued. He asked if I could identify the motif: a small rectangle of sterling silver with a couple of holes and a P-shaped notch taken out of it - giving it the air of a Lilliputian bottle opener intended for a ritzy doll's house.

I recognised it with the familiarity of seeing an old friend. It depicted the façade of the original Hackett shop on Parsons Green – a curious low white building that seemed to think it was a wing of an Art Deco villa from the Cote d'Azur of the F Scott Fitzgerald years, rather than a second hand clothes shop in what was then the Poor Man's Chelsea.

That was in 1983.

Much has changed over the intervening decades.

One doesn't talk about second hand clothes these days; the correct term is vintage. I cannot remember the last time I saw a poor man in Parsons Green. Hackett has taken its place in the constellation of world famous names that make up the international retailscape. And Jeremy does not just share his name with a shop, he has shared it with all of us: Hackett has entered the English language as an adjective; a couple of syllables with the power to summon an entire world of mildly eccentric, wryly humorous, impeccably mannered understatement – the world of essential British kit… the world of Jeremy Hackett.

About the only thing that has not changed much since 1983 is the man himself. He smiles the same crooked smile. He speaks in the same subdued tone, with the same humorous manner so gentle that you do not know you have been affectionately mocked until you think about it later. He wears the same sloping shouldered suits in grey West of England flannel. He exhibits the same fondness for puns with the air of Soviet slogans; 'Formal Dress is not fancy dress' being one of the most familiar.

In short if one did not know better one might surmise that fame had passed him by
leaving him unaltered, rather than transforming him into the highest authority on what it is
to look like a certain type of Englishman. But then, living the dream for Jeremy is not about yachts,
jets and penthouses. It is about having half a dozen impeccably perfectly tailored
suits hanging in his wardrobe; as well as a pair of cords and an elbow-patched tweed jacket for
walking the dog, or for the important (in) activity of sitting in a deck chair in the garden of
his London home and smoking a Hoyo de Monterrey Epicure No 2.

To those who know him Jeremy is much more than an ambulant menswear encyclopaedia.
He is a witty writer, on subjects as wide ranging as watches and motoring.
He is a talented photographer with an intriguing palette of aesthetic reference:
whether skateboarding; elderly neon signs; or a half smoked cigar - he has an eye that sees charm,
character and a unique sort of beauty where others would only capture banality.

This book is more than just the observations of a menswear giant.
It is a personal celebration of a life lived with inner as well as outer elegance /
and in its pages I hope that many (people) will get to know the kind, loyal and amusing man /
I am fortunate enough to call my friend.

Best regards,

Nick Foulkes

Chapter

1

BEING MR.CLASSIC

Being Mr. Classic

ミスター・クラシックになる方法

バックグラウンド

　私はイングランド西部ブリストルにあるクリフトンという町で育った。父はテキスタイルのビジネスをしていて、母はお針子だった。私は常に型紙と服地の見本帳に囲まれていた。母は編み物が非常に好きだったので、いつも私にセーターを編んでくれた。当時、私はそのセーターが時代遅れだと思い、嫌っていたのをよく覚えている。しかし、思い返してみると、柔らかなホームスパンの毛糸で編まれたセーターはなかなか良いものだった。今にして思えば、私が生涯を通してファッション業に関わることになったのは、避けられない運命だったのではないかと信じている。

最初のスーツ

　それは7歳のときだったに違いない。私がキリスト教の初めての聖体拝領の儀式のときに着るスーツについて、両親が大騒ぎしていたからだ。両親と一緒に地元のテーラーを訪れたとき、自分が何を着たいのか、すぐわかった。グレーのドニゴール・ツイードを選び、テーラーが着ていたスーツにあったチケットポケット(注1)をつけてくれと頼んだことを覚えている。私はかなり早熟な子供だったのだ。

(注1) 日本ではなぜか慣習的にチェンジポケットと呼ばれているポケットのこと。英国ではチケットポケットと呼ばれている。英国の通貨、特に小銭の1ポンドはかなり厚みがあるので、この小さなポケットにチェンジ（小銭）を入れるのはポケットが膨らんでかなり見苦しいと思う。

Background

I was brought up in Clifton, Bristol in the west of England. My mother was a seamstress and my father worked in the textile business, so I was constantly surrounded by paper patterns and fabric bunches. My mother was also passionate about knitting, and was forever making me pullovers. At the time I remember really disliking them, and thinking they were old-fashioned. But in retrospect I think they were actually rather nice, in a home-spun sort of way. Thinking back, I believe that it was inevitable that I would become involved in the fashion trade.

My first suit

I must have been seven at the time, because a great fuss was being made by my parents about my first holy communion, for which I would need to wear a suit. We made a visit to the local tailor, where I made it very clear what I would wear. I chose a grey Donegal tweed cloth, and I can remember asking for a ticket pocket, just like the one on the suit the tailor was wearing. I was a precocious child.

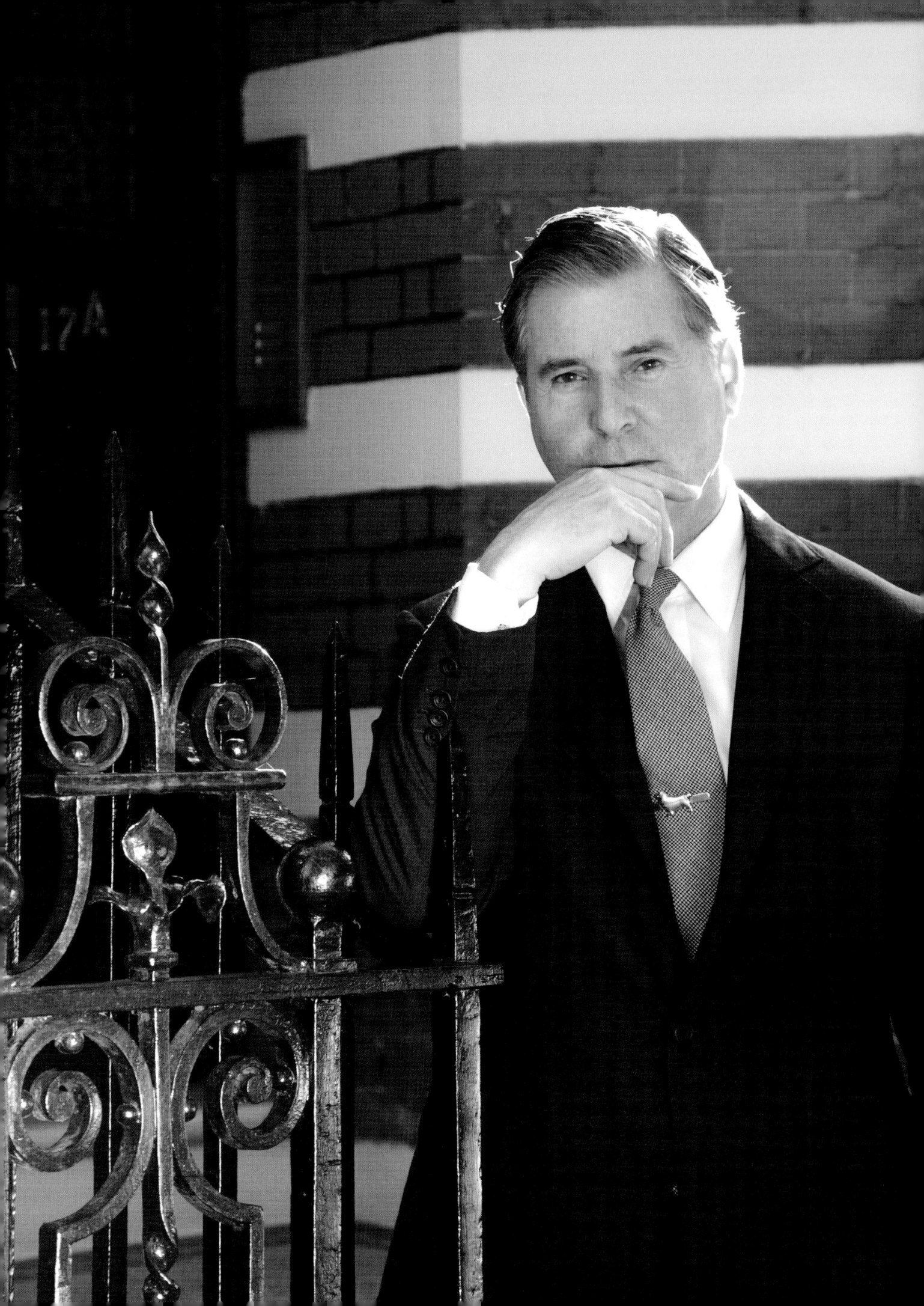

自分がスタイルについて感性があると いつわかったのか

　学校では制服に対するルールは厳格だった。ホワイトシャツ、レッドタイ、グレーのトラウザーズを身につけ、ブラックシューズを履かなくてはならなかった。ごく自然に反抗するようになったが、規則は破るものではなく曲げるものであり、その方が周囲から目立つ方法だとわかった。しかもそれなら規則を破ったとして退学になることもない。私のホワイトシャツはペニーラウンドカラーのものだったし、タイはニットのもの、グレーのトラウザーズは母に頼んでテーパードにしてもらった。紐付きのブラックシューズより黒のチェルシーブーツを履いた。すぐにクラス中の男子が私のスタイルを真似し始めた。規則には従ったが、私なりのやり方で従ったのだ。

ブリストル

　学校の試験にことごとく失敗し、17歳で学校を中退した。そのような訳で、学生時代は充実した生活を送っていたとはとても言えない。当時、数学の教師は「心配するな、君の魅力と笑顔でなんとかなるよ」と言った。確かにその通りだった！父は学生時代最後の学校の成績表を見て、失望したようにため息をつき、「もっと真剣に考えないと、そこいらの店で働くことになるぞ」ときつく論された。しかし、それは私にとっては最悪の展開ではなかった。逆に、私にとって幸運なことに、父が言った通りに店で働くことになった。私はすでにその頃、土曜日は地元のテーラーでバイトをしていた。彼はとても寛大で、正社員として

When did you know you had an eye for style?

　At school there was a strict uniform. We had to wear a white shirt, red tie, grey trousers and black shoes. Naturally I rebelled against it, but I realised that bending the rules rather than breaking them would be the way to stand out from the crowd, without being suspended for being inappropriately dressed. So my white shirt had a penny round collar, my tie was a knitted one, my grey trousers I begged my mother to taper for me, and I wore Chelsea boots rather than black lace-ups. Soon all the boys in my class started to ape my style. I was abiding by the rules, but on my own terms.

Bristol

　It's fair to say that my school days were not a success: I left at 17, having failed all my exams. My maths teacher at the time said to me 'not to worry – you'll get by on your charm and your smile'. It seems to have worked so far! When my father received my final school report he sighed despondently and exclaimed, 'If you don't pull your socks up you will end up working in a shop' – as though that was the worst possible outcome. Fortunately that is exactly what happened.

採用してくれた。隣のブティックも経営していたので、そこでも働いた。その店ではさまざまな色の〝リーバイス〟のコーデュロイジーンズ、〝ベン・シャーマン〟のボタンダウンシャツ、シェットランドのクルーネックセーター、ギャバディン・トラウザーズとローファーを売っていた。このスタイルはモッズとスキンヘッドの中間、「スエードヘッド」と当時呼ばれていた。ブティックのバイヤーは出張に来るセールスマンから常時仕入れをしていたが、私はいつも彼に「ロンドンに行って自分たちで買い付けをした方が他のブリストルの店と差をつけられる」と言っていた。言い続けたことにより、説得に成功した私たちはロンドンに行き始め、キングズ・ロードにあったブティック、〝ザ・ヴィレッジ・ゲート〟〝クインシー〟や〝テイク・シックス〟に行った。70年代の初めにはとても人気があった店だ。〝デボネア〟というブランド名で、スーツとジャケットを作っていたが、ロンドンのイーストエンドにあった工場に行ったときのことは、今でもよく覚えている。私たちはスコットランド風のニットウェア、フェアアイルとアーガイル模様のセーターをデザインし始め、それから何年も経った後に、〝ハケット〟で同じ製造工場を使った。

ロンドン

19歳のとき、私の将来はロンドンにあるのではないかと思うようになった。当時有名だったキングズ・ロードにある〝ザ・ヴィレッジ・ゲート〟という店を知っていたので、そこで働こうと思った。ジェネラル・マネージャーのフィリップ・スタートが面接官だったが、そのときは彼にとても怯え

I already had a Saturday job in a local tailor's shop, and he very generously offered me a full-time position. The tailor owned a boutique next door, where I also worked. There we sold Levi cord jeans in numerous colours, Ben Sherman button-down shirts, Shetland crew-neck sweaters, gabardine trousers, and loafers – there was a moment when the look was referred to as 'Suedehead', a cross between Mod and Skinhead. The boutique buyer usually bought from the travelling salesmen, and I kept saying to him, 'We need to go to London and source the clothes ourselves so that we have something different to the other shops in Bristol'. So we started to make trips to London to check out the King's Road boutiques, The Village Gate, Quincy, and Take Six – all hugely popular in the early Seventies. I can remember visiting an East End factory that began to make suits and jackets for us with the name 'Debonair'. We started to design our own knitwear from Scotland – Fair Isle and Argyle slipovers – and many years later I worked with the same manufacturer for Hackett.

London

At the age of 19 I realised that my future would be in London, and being familiar with the then-famous Village Gate shops

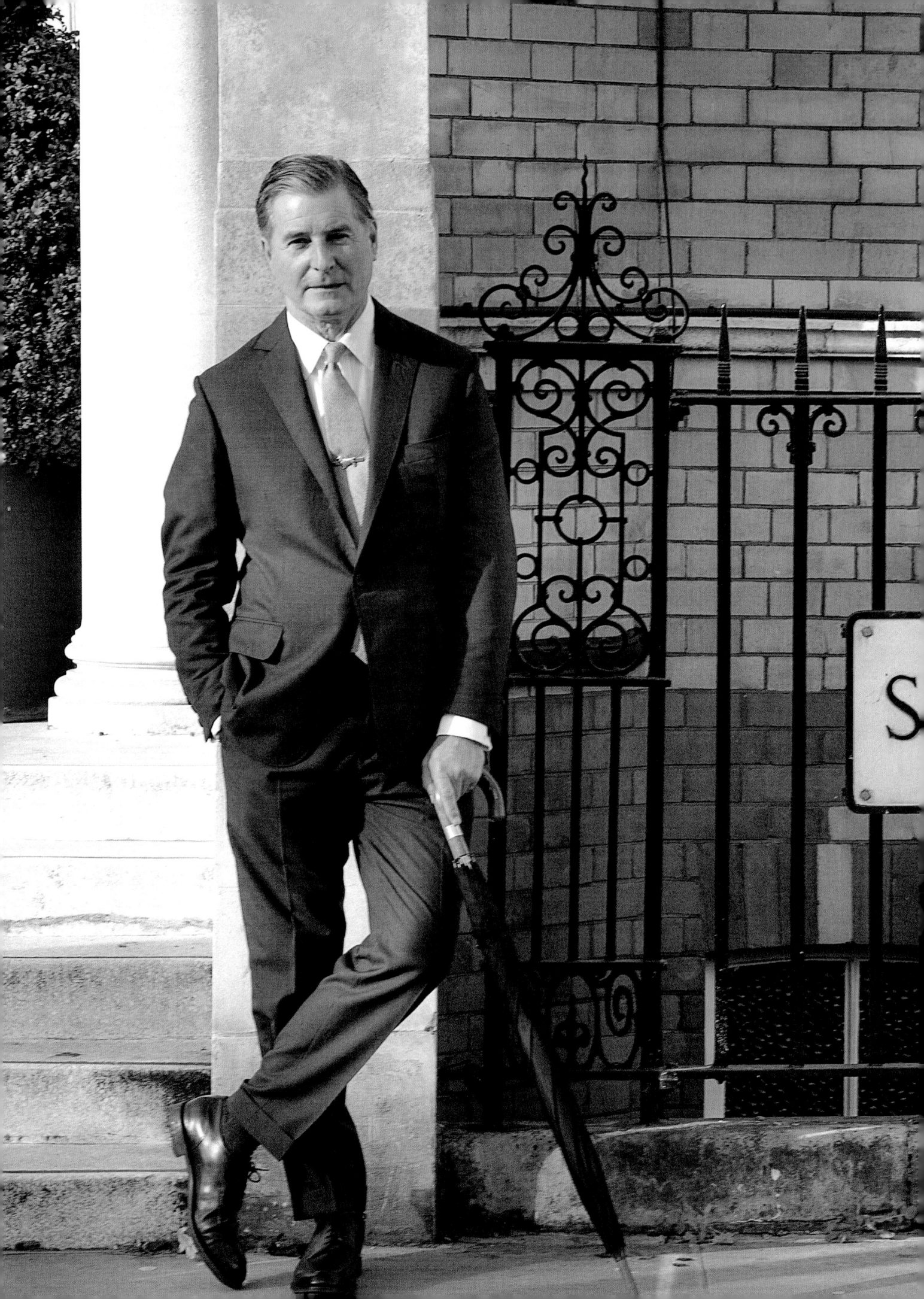

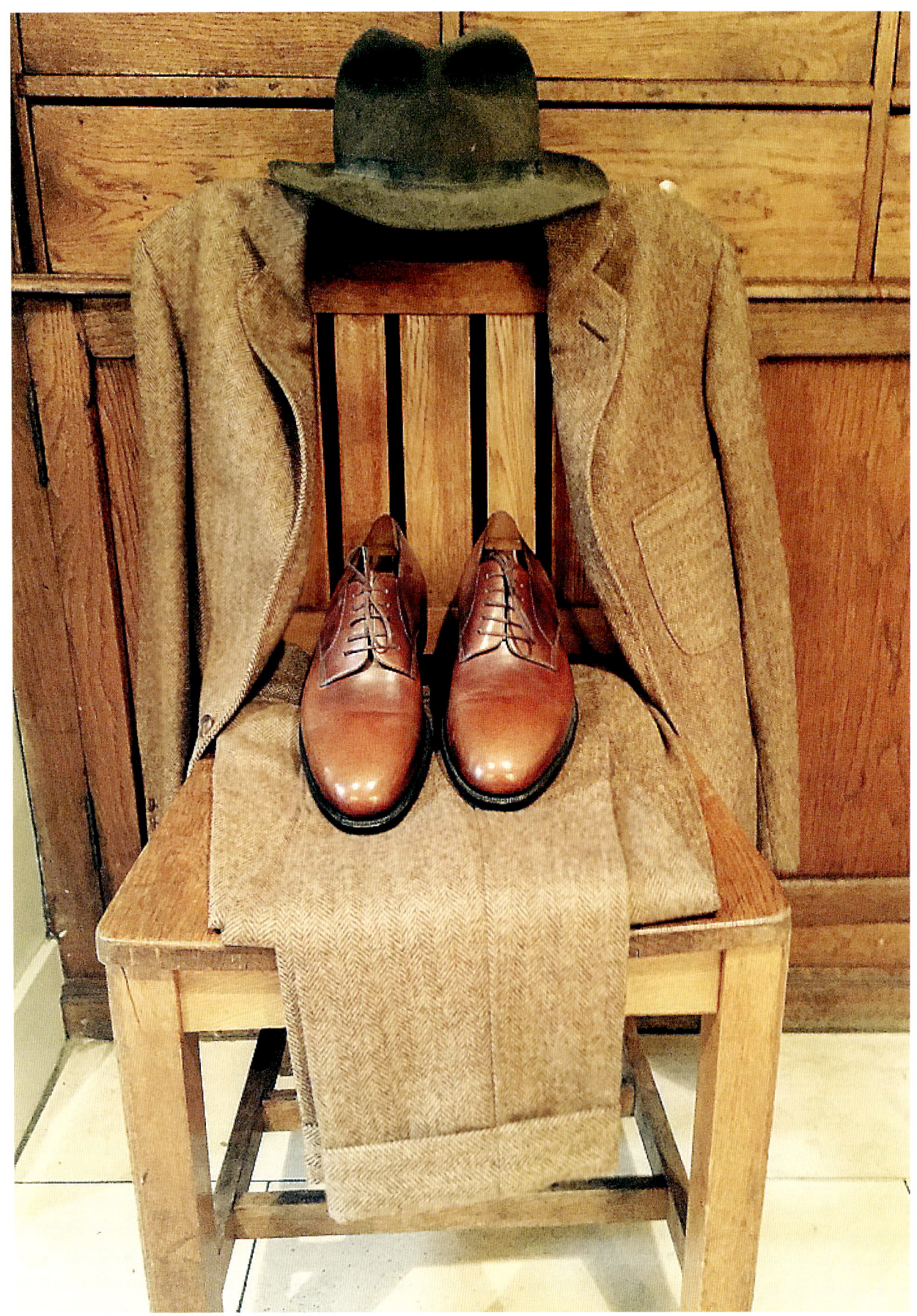

ていた。後にフィリップは自分のブランドを作ったのだが、ごく最近彼に会ったところ、非常に愛想のいい人だった。なぜ昔はあれほど怖がっていたのかわからない。ブリストルで働いていた頃の3倍の額の給料をもらっていたが、ロンドンの物価の高さをわかっていなかったので、いつも一文無しだった。〝ザ・ヴィレッジ・ゲード〟はキングズ・ロードにいくつかの店があった。新人の私は、シニアセールスマンに言われてシャツやジャケットを取りに店から店へと走り回った。非常に競争が激しかった。というのも、すべてのセールスチームはフルコミッションで、このとき初めて、私はリテール業の厳しさを体験した。しばしばマネージャーから売り上げが足りないと言われていたが、ここで多くのことを学んだ。

　数年後、サヴィル・ロウにあった〝ジョン・マイケル〟(注2)というテーラーで働かないかとオファーを受けた。純粋にインスピレーショナルな店で、サヴィル・ロウのどの店とも比較にならなかった。テーマカラーはブラウンとクリーム、クローム素材やブラウンスモークのガラス、シャギーなカーペット。70年代のコンテンポラリーファッションがそこにはあった。当然ながら、周囲のサヴィル・ロウの店からはひんしゅくを買っていたが、ジョン・マイケルはビジネスに対して情熱を持っていた。ブランドをどうやって構築するべきか、テーラリングの何たるかを私に教えてくれた最初の人間だった。店ではビスポークと同時に既製品も売っていて、私の仕事は、まずはじめに顧

(注2) ジョン・マイケル・イングラムはメンズウェア・デザイナー、ファッション・ジャーナリスト。1931年2月1日生まれ。2014年6月13日に亡くなる。1965年にサヴィル・ロウで株式公開し、1971年の火事の後、新しいショールームを開いた。

on the King's Road I applied for a job. I was interviewed by the general manager, Philip Start, who at the time frightened the life out of me. He later went on to build his own brand, and having met him more recently I wondered why I had been so scared because he was very amiable. I was offered three times what I had been earning in Bristol, but I didn't realise how expensive London was, and so I was permanently broke. I started in the King's Road, where there were several Village Gates. As the new boy I was constantly being told by the senior sales guys to run down the road and fetch a shirt or jacket from one of the other shops. It was a very competitive environment: all the sales team were on commission, and for the first time I experienced the hard edge of retailing. I was often berated by the manager for not selling enough, but it taught me a lot.

　After a couple of years I was approached and offered a job in Savile Row, working for John Michael, a truly inspirational retailer. His shop was like no other in Savile Row. It was fitted out in the contemporary fashion of the Seventies: the colour scheme was brown and cream with chrome fixtures, smoked glass mirrors and shag-pile carpets. It caused raised eyebrows among the more conservative tailors. John Michael was a man who

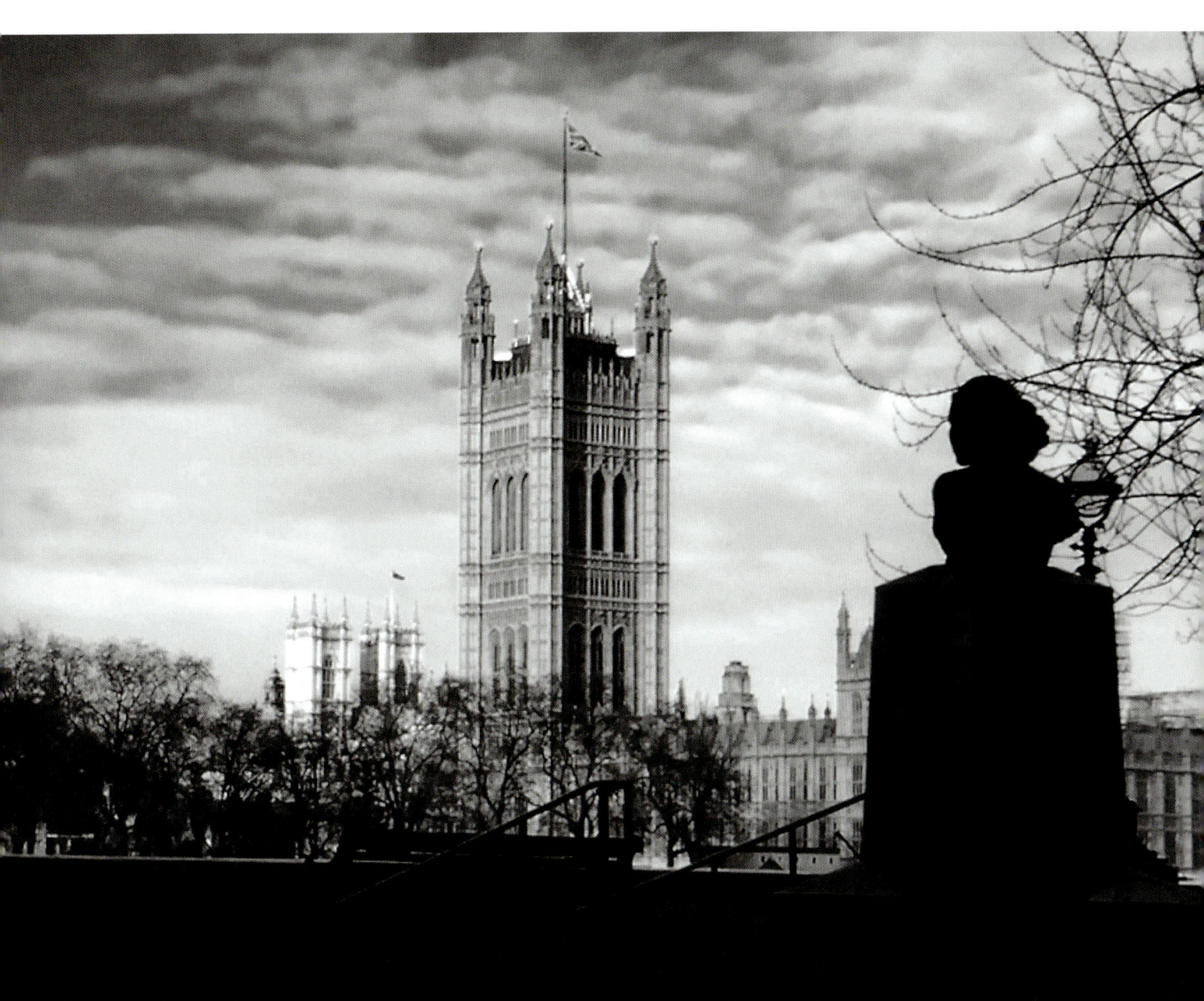

客に生地とスタイリングについてのアドバイスをして、それからテーラーに紹介することだった。当時、店には有名人がよくやってきたが、私にとってはそれがセレブリティと会う最初の体験だったのだ。私たちはスターたちに憧れている様子を絶対に表面に出すなと厳しく指導されていた。ジョン・マイケルはかつて言ったものだ。「すべての顧客がセレブリティだ」。今日に至るまで、私自身、この言葉を同じように反芻している。

古着

〝ジョン・マイケル〟ではたくさん稼いでいたが、相変わらず週の終わりには一文無しの有様だった。収入の足しにしようと、ポートベロー・マーケットに足繁く通い、こまごましたものを買った。私が見つけるものに興味を持っている友だちがいて、買ってきたものを彼らに売った。そのようなわけで金曜日と土曜日は仕事の前にポートベローに行っていたのだが、そこで会ったのがアシュレイ・ロイド・ジェニングスだった。彼も古着(セカンドハンド・クローズ)を探していたのだ。「ヴィンテージ」という言葉がまだ一般的でなかった頃のことである。私たちは自分がやろうとしているビジネスについて話し始め、どうせ二人とも同じことを考えているのだから一緒にやろうということになった。その日が長きにわたって実り多い信頼関係を築いていく始まりの日となった。ある日、一人のフランス人と出会った。彼は衣類に関連するあらゆる英国製品を買い付けていたのだった。彼は毎月ロンドンに来ていたのだが、彼から自分の仕事を手伝わないかと誘われた。私たちは彼と組むことにした。それは大正解だった。

was passionate about his business, and was the first person to give me an insight into brand building and teach me about tailoring. At the same time as selling the ready-to-wear clothes, my job was to introduce customers to the tailor, having first advised them about cloth and styling. It was my first brush with celebrities, and on most days someone famous would appear. We were under strict instructions not to show any signs of being star-struck. John Michael used to say, 'All my customers are celebrities' – and I find myself repeating the very same thing today.

Second-hand clothes

I was earning more money at John Michael, but still by the end of the week I was out of pocket. I decided I needed to supplement my income. Having been to Portobello Road market a few times buying bits and pieces, it occurred to me that I could sell a few things to my friends, who were always commenting on my clothing finds. I would go to Portobello on a Friday and Saturday before work, and one morning I met Ashley Lloyd-Jennings, who was also looking for second-hand clothes – the term 'vintage' had yet to be coined. We started chatting and decided that as we

私たちは成功して仕事を辞めることができた。毎日古着を探すことに時間を費やし、掘り出し物を見つけてはパリのポート・デ・クリニャンクールにある彼の露店へ持って行った。

シュー・ショップ（靴屋）

　フレンチ・コネクションが成功したので、物件に投資できるようになった。ロンドンのフラムにあるテラスハウスを何件か見つけて投資した。こうした物件はその当時は10,000ポンドで買えた。しかし今や超高級住宅街となり、今では何百万ポンドもしている。二人とも靴が好きだったので、その物件を売って金をつくり、コベントガーデンにある古い倉庫で高級靴を扱う靴屋を始めた。まだコベントガーデンが荒廃した地域だった頃のことだ。〝ロイド＝ジェニングス〟と呼ばれたその店では〝オールデン〟のクラシックなタッセル・ローファーを扱い、英国製の靴はすべて〝エドワード・グリーン〟製だった。固定客ができたことに勇気付けられ、金融街に一店舗、さらにもう一店舗オールド・ボンド・ストリートにオープンさせた。しかし経営がうまく行かず、利益を出すために3年間奮闘したが、最後は資金が尽きて、銀行の抵当流れとなった。住んでいたマンションを失い、私たちはすべてを無くして一文無しとなり、振り出しに戻ってしまった。今思い出しても非常に辛い経験だった。

最初のハケットの店

　80年代はじめの頃になる。アシュレーと私は馴染みのポートベロー・ロードに戻り、例のフラ

were both doing the same thing we would pool our resources. It was the beginning of a long and fruitful partnership. One day we bumped into a Frenchman who was buying up everything British and clothing-related. He explained that he came on buying trips to London every month, but why didn't we buy for him? It proved to be very successful, so much so that we were both able to give up our jobs and spend our days sourcing second-hand clothes, which we took to his stall at the Porte de Clignancourt in Paris.

Shoe shop

　The success of our French connection allowed us to invest in property. We found a couple of terraced houses in Fulham, which at the time you could buy for £10,000 – they are now all bijoux residences that cost upwards of a million. We both had a fondness for good shoes, so with the capital we had raised from selling the properties we decided to open a shoe shop in an old warehouse in Covent Garden. This was when the area was a virtual wasteland. The shop was called Lloyd-Jennings: we stocked the classic American loafers from Alden, and Edward Green made all our English shoes. We began to gain a loyal following, which encouraged us to open a shop in

ンス人とのビジネスを再開した。数年間、古着を詰め込んだ車での買い付け旅行を繰り返した。フランスのカレーからパリへとドライブしていたある晩、路面が凍結して車がスリップした。車（ラブリーなBMW1602）は道を外れ、数回転倒して、最後は溝にはまり、止まった。二人ともかすり傷ひとつなく車から出られたのは良かったが、車は廃車となった。数時間後、私たちは警察に拾ってもらい、親切にも彼らはパリまですべての荷物を運んでくれた。危うい救出劇だったが、私たちの週末は大変楽しいものとなった。今思えば、アドレナリンでハイになっていたに違いない。私たちは定期的に行かなくてはならないこうした買い付け旅行に疲れ、ロンドンで古着を売ることを決心した。そのために私たちの少しの資産に加え、銀行から幾ばくかの融資を受け、フラムの住宅街に小さな店を構えた。当時、その地域は高級住宅地になり始めたばかりで、作家のピーター・ヨークが名付けた新人類「スローン・レンジャー」（注3）の住んでいる地域として有名になっていた。それと同時に、融資してくれた銀行が言うには、その地域は販売には向かない、小売業の墓場だという。結果として彼らが間違っていたことを証明できたのは、実にいい気分だった！ 自分たちで店の内装をし、マーケットで古い店のマホガニーの内装材を仕入れ、パリから古い真鍮の洋服用レールを買った。壁はひどい状態だったので、ブルー＆ホワイトのシャツ生地で覆った。スーツとジャケットは木製のハンガーにかけ、すべての商品は

(注3) スローン・レンジャーはロンドンの高級住宅街チェルシーからベルグレイヴィアにかけての周辺地域、スローン・スクエア周辺に住む、上流階級に属し流行に敏感な若者たちを指す。1980年代に流行した造語で、英国では社会現象ともなった。

the financial district and one in Old Bond Street. We struggled for 3 years to turn a profit, and in the end we ran out of capital and the bank foreclosed on us. We lost our flats, so we were back to square one. It was a painful experience.

The first Hackett shop

By now it was the early Eighties. Ashley and I returned to familiar ground on Portobello Road and resumed our working relationship with our Parisian colleague. For a couple of years we made regular trips with the car packed with second-hand clothes. Driving down from Calais one night on our way to Paris we skidded on black ice. The car (a lovely BMW 1602) veered off the road, turned over several times and ended up in a ditch. We both got out without a scratch, but the car was a write-off. A couple of hours later we were picked up by the police, who drove us with all our luggage to Paris. It was a narrow escape, but our weekend turned out to be a lot of fun – I think we were high on adrenalin. But we had both become tired of the constant trips, and so we made the decision to sell second-hand clothes ourselves in London. We opened a little shop in the residential district of Fulham. By this time the area had become gentrified, inhabited by a new tribe

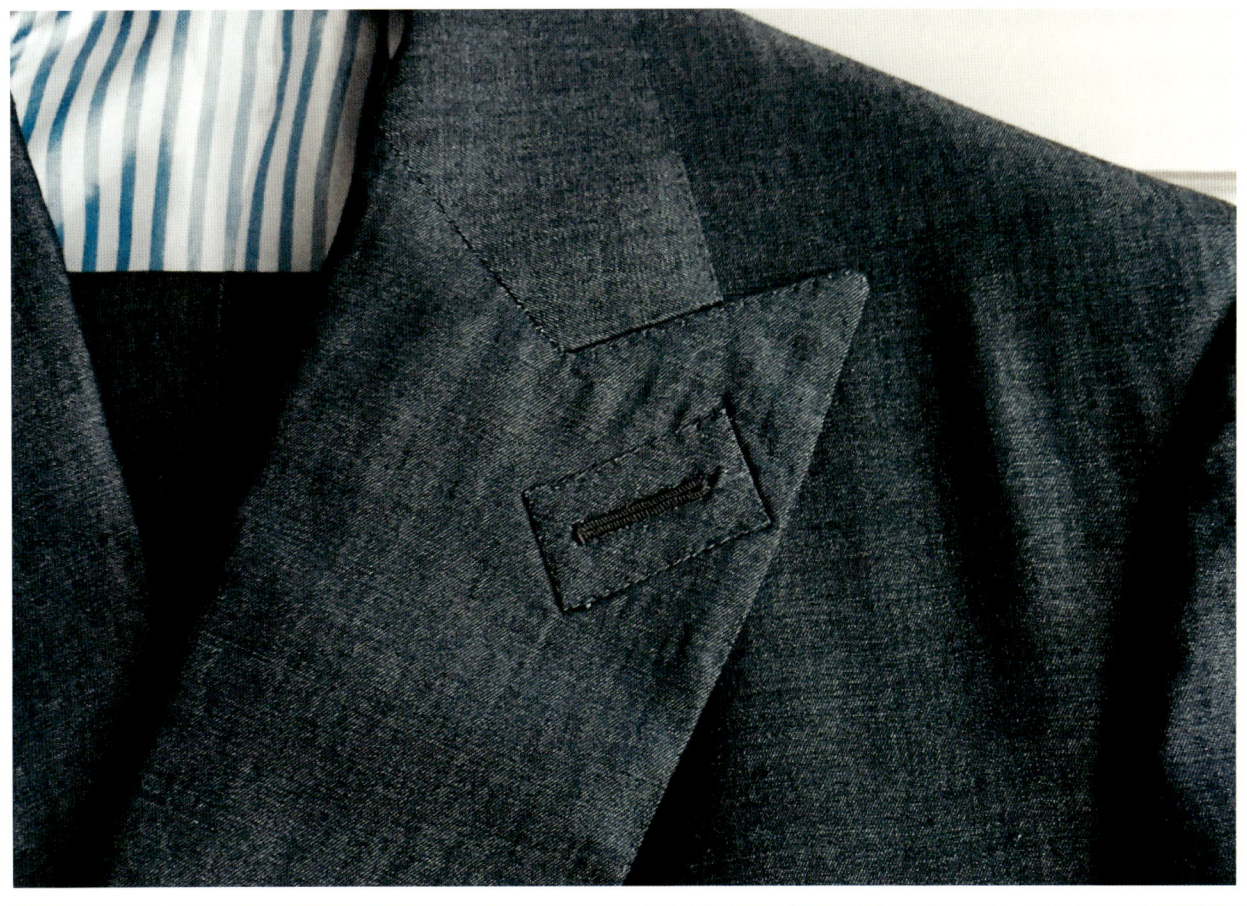
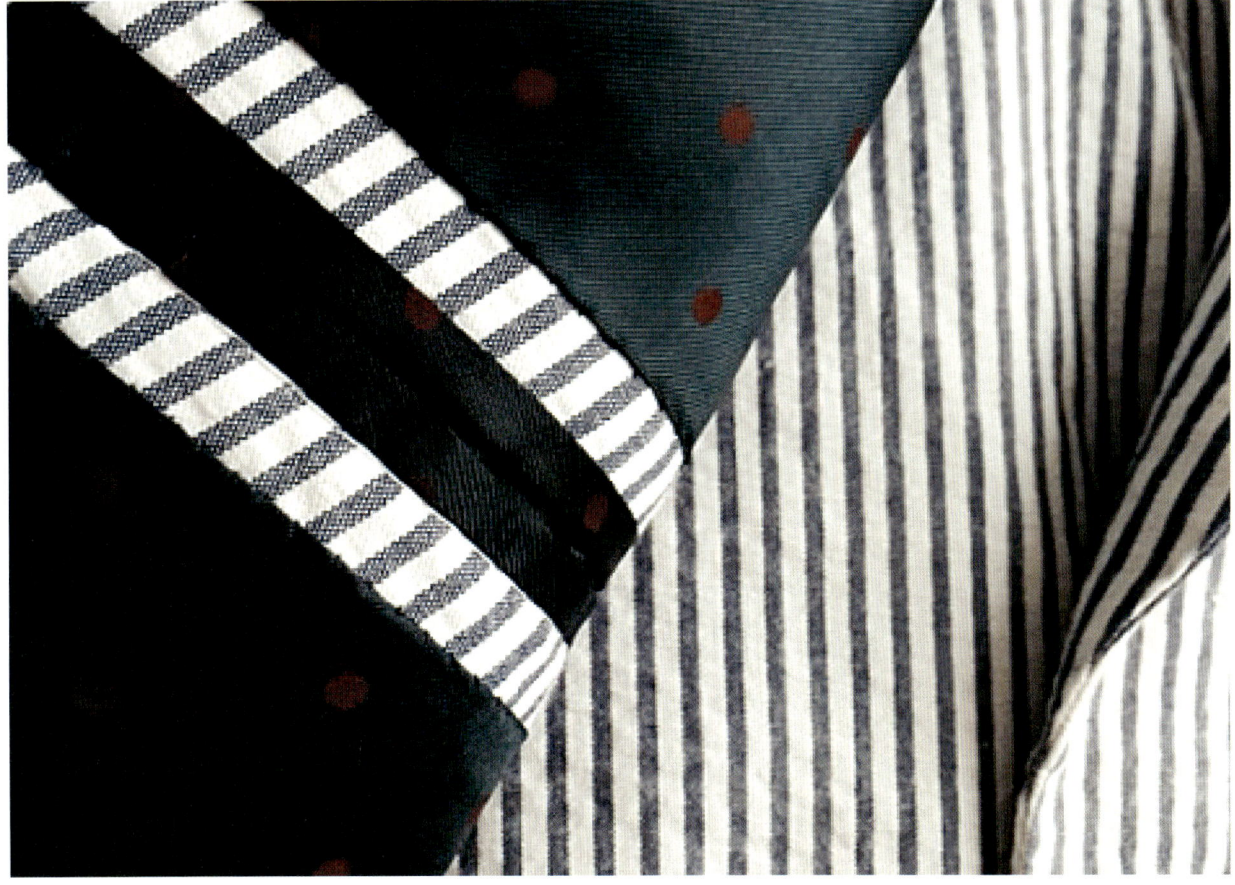

まるでサヴィル・ロウにある店のように整然と並べられた。

今までロンドンには、そんな古着の店は存在しなかった。店はオープンと同時に評判となり、常に大勢の客が押し寄せるようになった。インスピレーションを得るために世界中からデザイナーがやってきた。ラルフ・ローレンもそのひとりで、ハンティングに関するものなら何でも買っていった。後になって気がついたのだが、あのとき買っていった商品が、彼が立ち上げたクロージング・ラインのインスピレーションの源になったのだろう。ファッション・ジャーナリストのスージー・メンケスにインタビューされたときのことだ。彼女は〝ラルフ・ローレン〟と〝ハケット〟の違いは何かと訊ねてきた。私は「いうなれば〝ラルフ・ローレン〟はニュー・イングランドであり、対して〝ハケット〟はオールド・イングランドだ」と答えた。店に名前はなく、ドアに店の名前を掲げるまで6ヵ月は過ぎていたので、顧客の間では私たちの店は小さな丸いウィンドウがある奇妙な店として知られていた。前の店は〝ロイド＝ジェニングス〟と呼ばれていたので、今度の店の名は〝ハケット〟になった。ついに、私の名にライトが当たる番がやってきたのだ。

ヴィンテージ・ソース

当時は多くのストリート・マーケットがあり、古着を探すことができた。ブリックレーンは日曜日の朝5時ともなると実に多くの商品に溢れていた。数時間物色した後、カムデンタウンへ行き、それからイズリントンのチャペル・ストリート、最後にグリニッチ・マーケットを回

made famous by the writer Peter York, who called them Sloane Rangers. We pooled our limited resources and the bank contributed a modest sum, saying at the same time that the area was a retailers' graveyard. We were happy to prove them wrong! We decorated the shop ourselves, and bought old mahogany shop fittings from the market and old brass clothing rails from Paris. The walls were in such bad order that we covered them in lengths of blue and white shirt material. All the stock was laid out as though you were in a Savile Row tailor's shop, and the suits and jackets were hung on wooden hangers.

It was definitely like no other second-hand shop in London. It took off almost at once, and was constantly mobbed. Designers from all over the world came looking for inspiration. Ralph Lauren would pay us a visit and buy all sorts of hunting kit, which later I noticed had inspired one of his clothing lines. I was once interviewed by fashion journalist Suzy Menkes and she asked what was the difference between Ralph Lauren and Hackett. I replied that Ralph is New England and Hackett is Old England. It must have been about six months before we put a name above the door. People just referred to it as the shop with the funny round window. Because our previous venture had been called Lloyd- Jennings

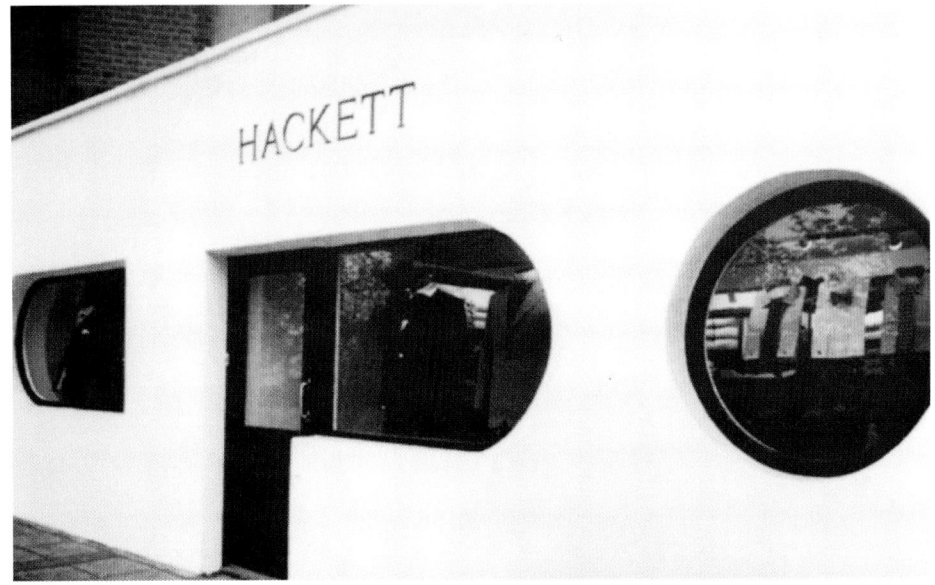

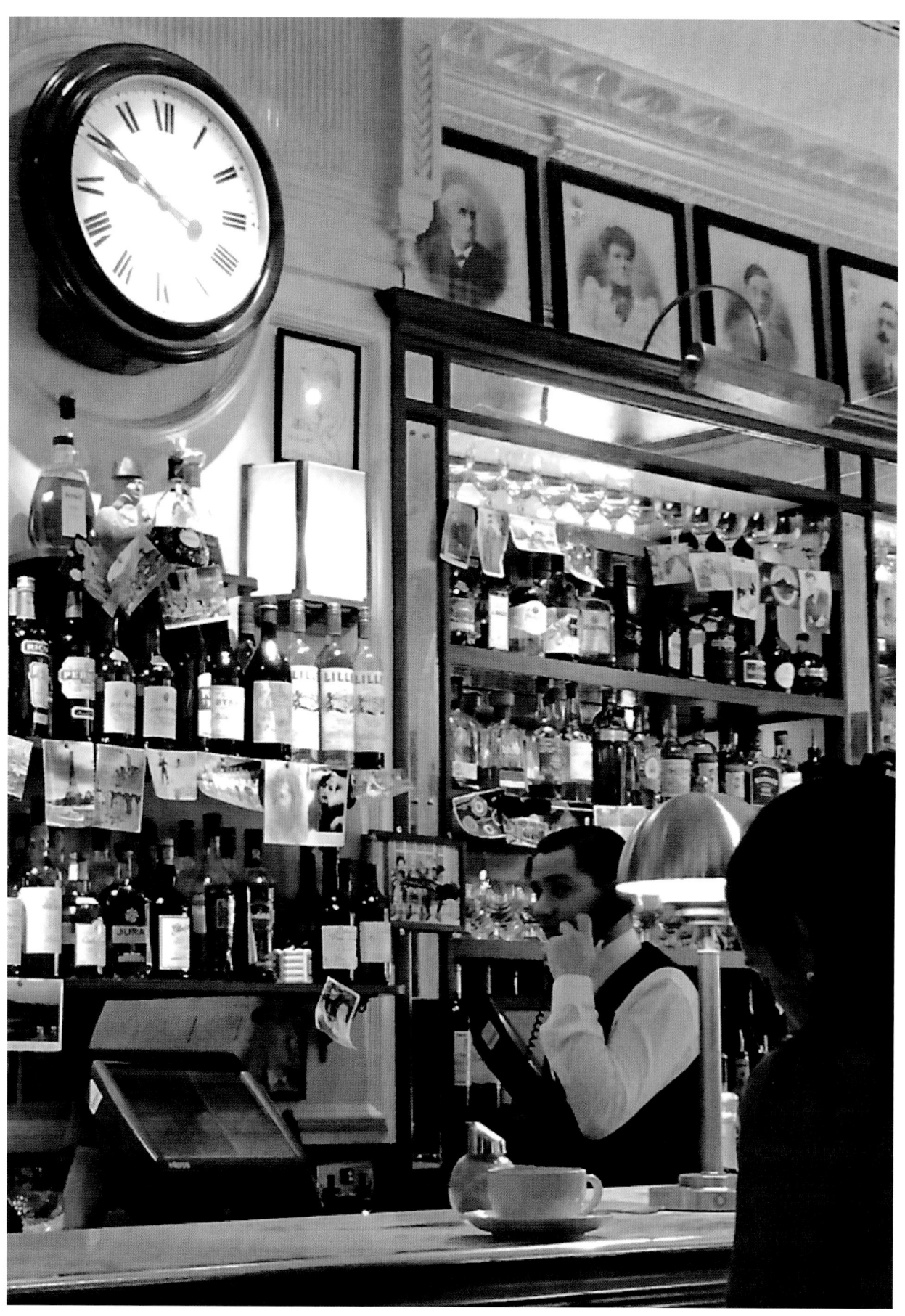

るのがいつものコースだった。それから店に戻り、ドライクリーニングへ出すものと、洗濯に出すシャツとを選別した。靴とライディングブーツはどんな状態のものでも磨き、月曜日の朝の仕事に備えた。私にとってマーケットに行く最大の醍醐味といえば、どんな物が見つかるかわからない、掘り出し物を発見するスリルである。およそ25足の〝ジョージ・クレヴァリー〟製、シューツリー付きの靴を1足5ポンドで見つけ、1週間も経たないうちに1足75ポンドで売ったこともある。こうしたヴィンテージ用品はかなりの需要があったので、私はさらに遠くまで足を運び、買い付けに行くようになった。古着屋やチャリティ・ショップ（不要になったものを寄付し、販売する店。売上は慈善団体に寄付される）や地元のマーケットを訪ねて、英国中を探索するようになった。数日間買い付けで家を離れると、商品を満載した車で戻った。ある日、ひとりのご婦人から電話があった。夫が亡くなったので、彼の遺品となったワードローブを整理したいと思う。ついては興味があるかという話だ。すべてハンドメイドでハイクオリティだと彼女は電話越しに言った。ロンドン近郊のサリー州にある彼女の家まで車で向かったところ、それは私が今まで見た中では最大のワードローブだった。スーツ、ツイードのカントリーウェア、ブラックタイ、ホワイトタイ、ヴェルヴェットのスモーキングジャケット、シルクのドレッシングガウン、大量のハンドメイドの靴とシャツ。それらは私にとってはまるで発掘された財宝だった。一日をそこで過ごし、彼女とランチを一緒にした。帰りの車は屋根まで貴重な洋服でいっぱいだった。彼女からは約50着のテーラーメイドのスーツを買ったが、すべてに〝ア

we finally named the shop Hackett. It was my turn to have my name up in lights.

Vintage sources

At the time there were many street markets where I could find second-hand clothes. Brick Lane was a rich source at 5am on a Sunday morning, and having scoured it for several hours I would make my way to Camden Town, and then on to Chapel Street in Islington, finally ending up at Greenwich Market. I would then return to the shop, sort out everything to be sent to the dry cleaners and shirts for the laundry. Any shoes or riding boots I had bought would be polished, ready for business on Monday. What was so enjoyable for me was the thrill of the chase, never knowing what was going to turn up. I remember picking up about 25 pairs of George Cleverley shoes with trees for a fiver a pair, and selling them on within a week for £75 a pair. Demand was so high that I needed to travel further afield. I began to search all over the country, visiting other second-hand shops, charity shops and local markets. I would be away for several days at a time, coming home with a carful of booty. One day I had a call from a lady whose husband had died, asking if I'd be interested in buying his wardrobe of clothes. She told

ルパート・サーストン"のフエルトのブレイシズ（サスペンダー）が付いていて、それをスーツとは別に販売した。非常に利益が上がった週末だった。私たちはニッチなマーケットを見つけていた。私たちの商品を買う若者たち、彼らの父親の世代はオーダーメイドのスーツを作ることができた。だが、彼らの世代にはオーダーメイドのスーツは高価すぎて、もはや買うことはできなくなっていた。しかし、ありふれた既製品のスーツを買うよりは、古着でもクオリティの高いビスポークのスーツやジャケットを買うことを彼らは好んだ。

ハケット・ツイード・ジャケット

私は今でもマーケットに行くのが好きだ。チャリティ・ショップの前を通りがかったら、万が一何か掘り出し物を見つけたらと思うと、入らずにはいられない。最近のことだが、ポートベローにいたときに（さすがに午前5時ではない。そうした時代は既に過ぎ去ったのだ）、レールにかかった古いツイードジャケットを見ていたら、見覚えのあるジャケットが目に止まった。売っている女性に、なぜ他のジャケットよりこれは高いのかと訊いたところ、「"ハケット"だからよ、知ってるでしょう」という答えが返ってきた。マーケットで宝探しをしていた初期の時代、私はガラクタの中にあるビスポークスーツをすぐに探し出すことができた。ほとんどの場合、スーパーマーケットにある"マークス&スペンサー"のスーツと同じくらいの値段で売られていたが、業者はほどなくしてそれに気がつくようになった。

古着のビジネスはあらゆる意味で大変やりがいがあったが、最も重要なのはクオリティだとする

me that they were all handmade and of the highest quality. I drove down to her house in Surrey, where I was confronted by the largest wardrobe of clothes I had ever seen: suits, tweeds, black tie, white tie, velvet smoking jackets, silk dressing gowns, handmade shoes and shirts galore. It was a veritable treasure trove. I spent the whole day there and was invited to lunch. I left with my estate car and roof rack overflowing with prize clothes. I bought about 50 tailormade suits, which all had Albert Thurston felt braces that I removed and sold separately. It made for a very lucrative weekend in the shop. We had found a niche in the market, supplying clothes to young guys whose fathers had enjoyed having their clothes made but who were at an age where the price for them was prohibitive. So rather than buy ordinary ready-to-wear suits they preferred to pay the same money and buy a good second-hand bespoke suit or jacket.

Hackett tweed jacket

I still love going to the markets, and if I pass a charity shop I have to go in, just in case. Not so long ago I was in Portobello (not at 5am – those days have long gone) and was looking through a rail of old tweed jackets and I spotted one that looked familiar. I asked the lady

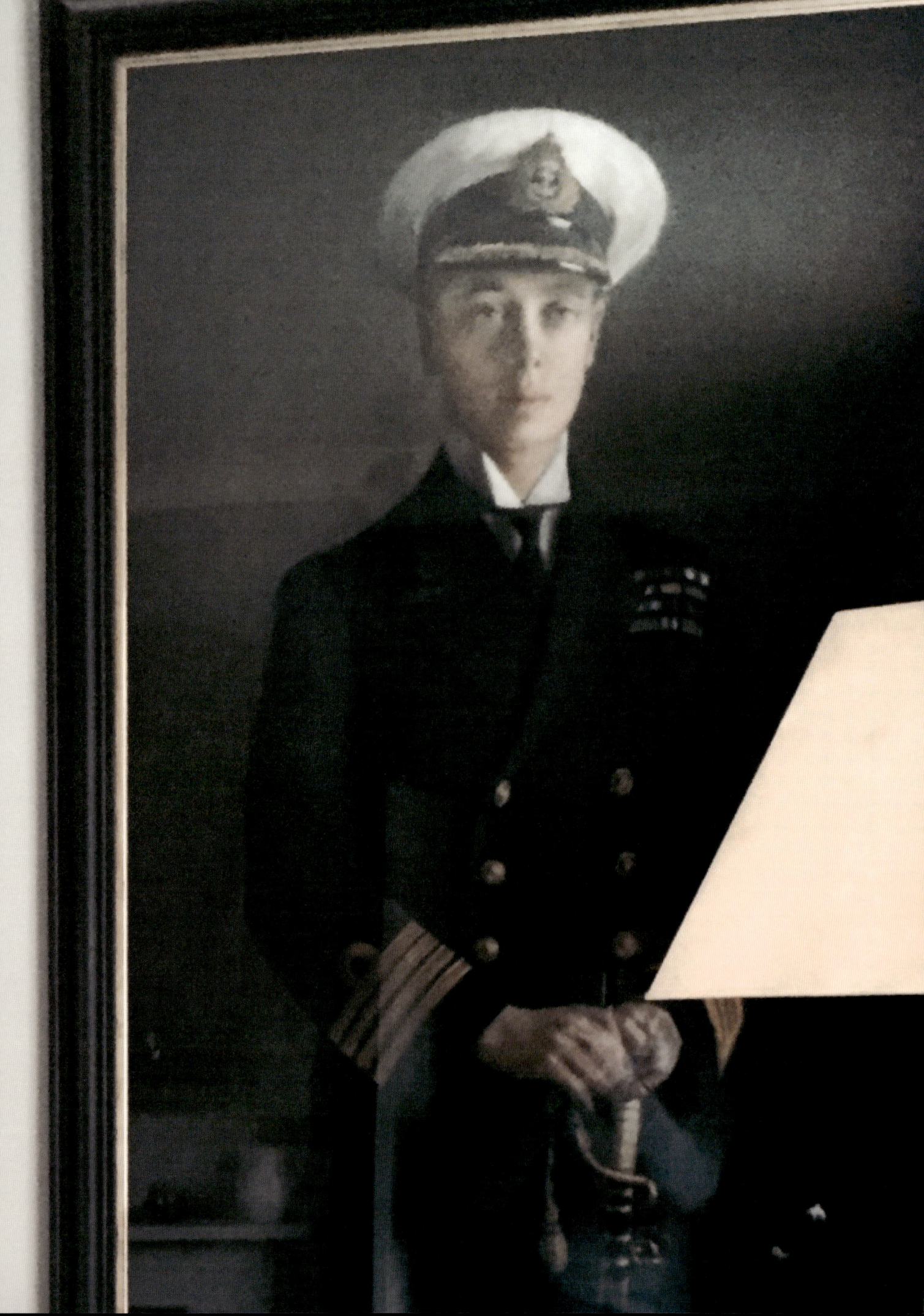

と、こうした需要に追いつくのが次第に厳しくなっていった。私はクオリティに妥協をしたくはなかったし、マーケットに溢れる単なる古いものを買うことで私たちの名を落としたくなかった。そこで、温めていたアイデアを実行に移すことにした。顧客にとても人気があった古着のスタイルをベースに、よく吟味された新しいクローズ・ラインを立ち上げるのだ。その頃は誰もがバギースタイルのダブルブレステッド・スーツを売っていたのだが、私たちはもっとテーラード的なアプローチを選んだ。既製服ではなく、サヴィル・ロウのスタイルを選んだのだ。イングランド北部にはまだ数件の製造工場が残っていて、そこでスーツとジャケットを製造することにした。何着かの古いビスポークスーツを持って彼らを訪ね、こうしたものが作りたいと注文した。そこでは返ってくる答えはいつも同じだった。「もう何年もこうしたものは作っていないが、本当にブレイシズをつける仕様のトラウザーズやワーキング・ボタンカフ仕様（本切羽）のものを作りたいと思っているのか？」。ファブリックはサヴィル・ロウで使用しているミル（紡績工場＆メーカー）と同じものを使った。生地をバルク単位で買えば、価格をより競争力のあるものにできたからだ。最初はスーツとジャケットの小さな単位からはじめ、トラウザーズ、シャツ、タイを加えた。

顧客に受け入れられるまでには少々時間を要した。なぜなら彼らは古着を好んでいたからだ。だが、彼らは自分が思うようなジャケットを古着から見つけられないことに苛立って、新しいラインも見るようになった。すると、彼らはそのカットとクオリティに驚き、喜んだ。もちろん、その価格にも。私たちはさらに店を数店舗オープンさせた。

why it was more expensive than all the others, and she replied, 'It is Hackett, you know'. In the early days of my forays into the markets I could spot a bespoke suit among all the rubbish, and most of the time it would be priced much the same as the Marks & Spencer suits. Dealers have since wised up.

While the second-hand business had been very rewarding in all senses of the word, we began to realise that we were struggling to keep up with the demand, and more importantly the quality. We didn't want to compromise our name by trading down and just buying any old thing that came our way, so we embarked on the idea of making a very edited line of new clothing, based on the type of second-hand clothes that had been so popular. At the time everyone was selling baggy double-breasted suits, but we opted for a more tailored approach: the look of Savile Row, but ready-to-wear. There were still a number of manufacturers in the North of England where I could have suits and jackets made. I would visit them with a few old bespoke suits and say this is the sort of thing I want. Invariably they would answer, 'We haven't made suits like that for years – are you sure you want the trousers made for braces and working button cuffs?'. I would source cloth from the same mills that Savile Row used, and

すべての店は50ヤード（約45メートル）以内にあったが、どの店も扱う製品にそれぞれ特徴があった。タクシードライバーはこのエリアを「ハケット・クロス」と呼び始めた。ロンドンのシティに２店舗、パリに１店舗、マドリッドに１店舗と次々に店を開いた。それが最初のスペインとのつながりで、大きな成功を収めた。しかし少しずつビジネスの基盤作りや専門的なノウハウが必要になってきていた。思えば、このとき、私たちは二人とも投資家の必要性を感じていて、そろそろ〝ハケット〞を次のステージへ引き上げる頃だと自覚した。

ダンヒル

　90年代のはじめの頃だった。日本企業が英国ブランドに膨大な投資をしていた時代である。彼らが〝ハケット〞の買収に興味を示しているという噂が流れた。これを聞いた〝ダンヒル〞が即座に反応して話に入り、〝ハケット〞の買収を決めた。こうしてわれわれは新たな経済援助を受けて、ブランドを拡大し、スローン・ストリートにフラッグシップ・ショップをオープンする機会を得た。それは私のお気に入りの店で、今でも残っている最上の店舗のひとつだ。その後、〝ダンヒル〞が〝リシュモン〞（スイスを本拠地とする企業グループ）の傘下に入るまで、この調和の取れた良好な信頼関係は続いた。しかし〝リシュモン〞は彼らの長期のブランディング戦略に〝ハケット〞は適合しないという結論を下したのだ。私にはその決定がよく理解できる。なぜなら彼らの本業はジュエリーと時計なのだ。その後、〝ハケット〞はスペインでの成功によって、スペインを地盤とする〝ペペ・グループ〞

because I was buying in bulk the price was more competitive. We started with a small range of suits and jackets, adding trousers and shirts and ties.

It took a while to take off, because customers preferred to buy second-hand. But they became frustrated at not being able to find say the right jacket, and so they began to look at the new ones and were pleasantly surprised by the cut and quality – and of course the price. We soon opened several more shops, all within about fifty yards of each other, each specialising in various aspects of clothing. Taxi drivers began to refer to the area as Hackett Cross. We opened a couple of shops in the City, one in Paris and one in Madrid, which the Spanish took to from day one. It was becoming a big business, one that needed more infrastructure and more expertise. I think we both realised that it was time to look for investors to take Hackett to the next stage.

Dunhill

It was now the early Nineties. The Japanese were investing heavily in British brands, and it had been rumoured that they had expressed an interest in purchasing Hackett. It so happened that Dunhill heard about it and jumped in and bought the business from us outright.

が〝リシュモン〞と交渉することになり、買収が決まった。このようにすべてのことが良好に運び、過去10年間でスペインの投資家は飛躍的にブランドを成長させた。フラムで古着を売っていた小さな店から、広く世界で認識されるインターナショナルなブランドへ成長を遂げたのだ。一体誰がこれを想像できただろうか。

ブリティッシュ・ブランド

顧客やジャーナリストに、〝ハケット〞は創立してから何年になるかと訊かれたとき、私が30歳のときに始めたのだというと、彼らは非常に驚く。ブランドが昔からずっと存在していたようだというのだ。ほとんどの人が私の父か祖父がブランドを始めたと思っている。実際のところ、私は人生の大半を〝ハケット〞に費やしているのだが。

With new financial backing we were able to expand the brand, and it gave us the opportunity to open a flagship store on Sloane Street. It remains one of our best shops and is a favourite of mine.

We enjoyed a harmonious relationship with Dunhill until they went through a restructuring of their portfolio of brands under the Richemont umbrella. It was decided that Hackett no longer fitted in with their long-term plans, and I fully understood because their real expertise lay in watches and jewellery. Due to our success in Spain, the Spanish-owned Pepe group approached Richemont and a deal was struck. For all parties it has worked out well, and our Spanish investors have grown the brand tremendously in the past ten years. From a little shop in Fulham selling second-hand clothes to a widely recognised international brand – who would have thought it?

British Brand

When customers or journalists ask me how old the brand is they are astonished when I say that I started it when I was thirty. They seem to imagine that it is an ancient institution, started by my father or grandfather. Well, for me it's been pretty much a lifetime.

LAFONE STREET SE1
LONDON BOROUGH OF SOUTHWARK

POOL OF LONDON
ANCHOR BREWHOUSE ↑
TOWER BRIDGE
TOWER OF LONDON

Chapter

2

YESTERDAY & TOMORROW

My Favourite Find

私のお気に入り

　私はいつもポートベロー・ロードには早朝に行っていた。ポートベロー・ロードを歩いていて、一台の家具運搬用の車があった。側道の溝に置かれた包みが目についた。それが乗馬用ブーツだということはわかった。近寄って見てみると、並外れてコンディションの良い未着用のブーツだった。そこで男にいくらなら売るのか訊いてみた。「300ポンドってところかな」。商談成立だ。

　それから家に帰り、ブーツをじっくりと検分した。中を見ると驚かずにはいられなかった。インクで書かれた「HM ザ・キング」の文字があったのだ。そこで私はブーツをマスター・シュー&ブートメーカーであった〝ジョージ・クレヴァリー〟に持って行き、誰のために作られたと思うか尋ねて

　I was always in Portobello road early, and one morning I walked past a furniture van when suddenly a package was thrown out from the back into the gutter. I could see that they were riding boots. I took a quick look and realised that they were an exceptional pair and unworn. I asked the man how much he wanted for them, "give me three quid mate". I didn't haggle.

　When I got home I examined the boots more closely and to my astonishment inside, written in ink, it said HM The King. I took the boots to the master shoe and bootmaker George Cleverely

みた。彼はブーツを検分して、こう言った。「このブーツはトップの部分がシャンパンカラーになっているが、これはボーフォート・ハント(注1)で人気のあった仕様だ。当時、最も高名なブートメーカー、〝バートレー＆サン〟によって作られたものだ。足のサイズから推測するに、エドワード８世以外に考えられない」。

彼の説明によれば、エドワード８世が退位した(注2)とき、すでに国王の刻印が入れられていたので、このブーツは届けられることがなかった。ブートメーカーの家にあったブーツは、彼の死後、遺品整理で売りに出されて、ポートベロー・ロードのマーケットに辿り着いたに違いないと彼は信じていた。私はこのブーツを売らないことに決め、店のショーウィンドウに飾った。ある日、メトロポリタン美術館から人が来て、ダイアナ・ヴリーランド(注3)が「男と馬」と題した衣装の展覧会を行うという。「そのブーツをお貸し願えないでしょうか？」。私はブーツを貸すことに同意したが、果たして彼らが見積もった保険金額は3,000ポンドだった。1987年のことだ。今、そのブーツは東京の銀座店にあり、何人かがブーツを購入したいと莫大な金額を提示してきた。だが、それは売り物ではない。このブーツは、いつかチャリティ・オークションにかけるつもりだ。結局のところ、私は300ポンドしか払っていないのだから。

(注1) ボーフォート公爵の領地で行われるフォックス・ハンティング（狐刈り）のことを指している。10代目ボーフォート公爵（爵位1924年〜1984年）自身もハンティングの名手として知られた。
(注2) 1936年、イギリス国王として歴代最短の在位325日で退位。退位後はウィンザー公となった。
(注3) アメリカ『ヴォーグ』誌の編集長にして著名なファッション・エディター。ニューヨークにあるメトロポリタン美術館の衣装部門のコンサルタントでもあった。

and asked him who he thought they would have been made for. He began to examine them and said, "well they have champagne tops which were popular with The Beaufort Hunt and they have been made by the most prestigious bootmaker of the time, Bartley and Son. Judging by the size of the foot they could only have been made for Edward VIII".

He further explained that because Edward abdicated and the boots were already inscribed with his title, they could not be delivered. He believed they must have remained in the bootmaker's house until he died and during a house clearance they ended up in Portobello road. I decided not to sell them and placed them on show in my shop window. One day, someone from the Metropolitan Museum of Art in New York came into the shop and told me that Diana Vreeland was curating an exhibition of hunting clothes titled Man and the Horse and would I be prepared to lend them to the exhibition. I readily agreed and when they were valued for insurance purpose it was declared they were worth £ 3000.00 and that was in 1987. The boots are now on show at our Ginza store in Tokyo where several people have offered enormous sums of money for them, but they are not for sale. One day I will auction them off and give the proceeds to charity after all they only cost me three quid.

Shoes
靴

かつて父と私は日曜日の晩にある儀式を行っていた。翌週に備え、私は学校へ、父は仕事に行くための靴を磨いていた。あるとき、父は黒のブローグ・シューズを磨いていたが、最後の一磨きを終えるとこう言った。「安物のすぐだめになる靴を買うほど金持ちではない」。それ以来、この格言が私の心に残った。その結果、私の戸棚は良い靴でいっぱいとなった。

1986年、私にとって初めてのビスポークの靴は、たまたま俳優のテレンス・トランプの紹介からだった。彼はパーソンズ・グリーンにあった〝ハケット〟の一号店で私たちが古着を売っていた頃、よく店に顔を出していた。

ある土曜日の朝、テレンスがジョージ・クレヴァリーを伴って店にやってきて、私に紹介してくれた。ロンドンの卓越したシューメーカーとして彼の評判は知っていたが、実際に会ったことはなかったのだ。ダブル・ブレスティッドのグレーフランネルのスーツを着て、ケンブリッジ・ブローグと呼ばれるタン革のバックスキン、エラスティックのサイド・セミブローグを合わせていた。〝クレヴァリー〟のシグネチャーとして知られるサスピシャス・トウ・シェイプだった。ヴィンテージ・シューズの棚を見ると彼の目は輝き、一足の靴を取り上げると、〝トゥーシェック〟で自分が作った靴だと高らかに宣言した。1950年代の〝トゥーシェック〟といえば、彼の父、ブラザー・アンソニーと叔父、全員がそこで働いていた。驚いたことには、彼はその顧客が誰であったかまで覚えていたのだった。

その間にテレンスは店の中を見ていたが、3着のホワイト・バックスキンのブリッチズを持って戻ってきた。それは私がその日の朝、ポートベ

Growing up, my father and I had a Sunday evening ritual of polishing our shoes in preparation for the week ahead, me for school and him for work. On one occasion, as he was putting the final touch to a pair of black brogues, he remarked, 'I am too poor to buy cheap shoes.' It is a maxim that has remained with me ever since, and I now have a cupboard full of good shoes.

It wasn't until around 1986 that I indulged in my first pair of bespoke shoes. It happened purely through an introduction by the actor Terence Stamp, who from time to time popped into the original Hackett shop in Parsons Green, in the days when we sold second-hand clothes.

One Saturday morning Terence came in, accompanied by George Cleverley and introduced me to him. I knew of George's reputation as London's finest shoemaker, but had never actually met him. He was dressed in a double-breasted grey flannel suit, which he had teamed with tan buckskin elastic-sided semi-brogues, otherwise referred to as Cambridge brogues. They were made in his signature toe shape, known in shoemaking parlance as a suspicious square. His eyes alighted on a rack of vintage shoes, one of which he picked up and declared, 'I made these when I was at Tuczek in the 1950s',

Shoes

ロー・ロードのマーケットで買ってきたばかりのものだった。きちんと作られたもので、未着用、1930年代の〝ハンツマン〟で作られたものだった。テレンスがジョージにそれを見せると、バックスキンは最も美しい靴となるが、ここまで良いクオリティのものは何年も見ていないと言った。それを聞いて、テレンスは3本すべてを購入した。

彼らは店内を続けて探索していたが、ジョージが古いフェルトのトリルビー帽を試しているのを見て、その帽子を彼にプレゼントすることにした。彼が競馬好きだということを知っていたからだ。数週間後、ジョージに偶然ジャーミン・ストリートで遭遇した。すると彼は特別プライスで靴を一足作らせてくれないかと言ったのだ。もちろん、私はその機会に飛びついた。ジョージ・クレヴァリー本人に靴を作ってもらえる機会なのだから。

当時、彼は〝ニュー&リングウッド〟の階上にあった〝ポールセン&スコーン〟にいた。彼はブラックパンチド・オックスフォードの採寸をしたが、ほとんどの部分を目で採寸しているのがわかった。トウ・シェイプに対してディスカッションすることもなかった。それは（クレヴァリーを代表する）サスピシャス・スクエア・トウで、当然ながら私に口を出す資格もない。議論の余地はなかった。唯一、私が言えるのは、それが素晴らしい記憶に残る体験で、靴は夢のように足にフィットしたことだ。着古した競馬観戦用トリルビー帽をプレゼントしたことを心から喜んだ。それがなければ、初めてビスポーク・シューズを持つ喜びを享受することもなかったに違いない。

ジョージは90代まで靴作りを続け、その技術を若き同僚ジョージ・グラスゴーとジョン・カーメラが受け継いだ。1996年にジョージ・クレヴァ

adding that it was also where his father, brother Anthony and uncle all worked. To my amazement he even knew who the customer was.

Meanwhile Terence had been browsing, and returned holding three pairs of white buckskin britches that I had bought only that morning in Portobello. They were exquisite, unworn and had been made by Huntsman in the Thirties. Terence showed them to George, who immediately said the buckskin would make the most beautiful shoes and he had not seen such quality for many years, whereupon Terence bought all three pairs.

They carried on looking around. George tried on an old felt trilby, and knowing that he was a racing man I presented it to him as a gift. A few weeks later I bumped into George in Jermyn Street and he said let me make you a pair of shoes and I'll give you a really good price. Well of course I jumped at the opportunity to have a pair made by the man himself.

At that time he was based at Poulsen and Skone, upstairs in New and Lingwood. He measured me up for a pair of black punched Oxfords, but I could see that mostly it was by eye. There was no discussion about toe shape – it was to be the suspicious square, and who was I to argue? I can only say the experience was truly memorable, and the shoes fitted like

リーが亡くなったとき、ジョージとジョンはクレヴァリーの名前を引き継ごうと考え、靴箱ほどのサイズの店をロイヤル・アーケードに開いた。自然にその店はジョージ・クレヴァリーと呼ばれるようになった。初めての一足を作って以来、何足かの靴を作ってもらった。実際、正直にいうならば何足かではない。それ以上の数だ。

先日、店の前を通りかかったので、私の注文がどうなっているかを聞こうと、店に立ち寄った。〝ジョージ・クレヴァリー〟はプライベート・クラブのようなもので、中へアクセスするには入り口のベルを押さなければならない。どうやら私の靴はできあがっていたらしい（ここでは少なくとも完成に９ヵ月は要する。だが、待つ価値はある）。

ショーウィンドウに飾ってあるブローグ同様に磨き込まれた、カーブしたマホガニーの手すりがあり、その狭い曲がりくねった階段を上がって、ワークルームへ招かれた。そこでラスト（木型）が作られ、過去のラストもここに保管してある。若いスタッフも働いていて、この特別なクラフトが継承されていることを示していた。このことに気がついたのは新鮮な喜びだった。

職人のうちの一人は日本人だった。最近、日本にいたとき、ツートーンのノーウェジアン・シューズの荷物を引き取った（それは素晴らしかった）。卓越したシューメーカー、福田洋平の作った靴で、実際、彼は東京へ戻る前にクレヴァリーで修行し、帰国して自身のビスポーク・ビジネスを始めたのだった。

ジョージはすべての顧客の木型を保管している部屋を見せてくれた。多くの有名人の木型があったが、実際、有名人が多すぎて誰かひとりの名前を挙げるのが難しい。ジョージは私の木型をテレ

a dream. I was so pleased that I had given him that old battered racing trilby, or I may never have enjoyed the pleasure of my first bespoke shoes.

George carried on making shoes into his nineties, at the same time passing on his skills to his younger colleagues George Glasgow and John Carnera. When George Cleverley passed away in 1996, George and John were determined to keep the Cleverley name alive, and between them they opened a shoebox-sized shop in Royal Arcade, naturally called George Cleverley. Since that first pair I have had several pairs of shoes made – actually if I'm honest it is probably more than several!

The other day I was passing their shop so I called in just to see how my latest pair were doing. George Cleverley is like a private club – you have to ring the bell to gain access. Apparently my shoes were coming along (it can take at least 9 months to receive a completed pair, but it's worth the wait).

I was invited up the narrow winding staircase, with a curved mahogany handrail as highly polished as the brogues in the window, to the workroom where the lasts are made and stored. It was refreshing to notice that the staff were young, which bodes well for the continuation of this specialist craft.

ンス・スタンプとローリング・ストーンズのドラマー、チャーリー・ワッツの木型の横に吊り下げた。私は敬愛すべきメンバーの一員となったのだ。

以上の理由から、私は未だに日曜日の晩には靴を磨いている。

I noticed that one of the makers was Japanese, and I remembered that when I was last in Japan I took delivery of a pair of two-tone Norwegian shoes (they are wonderful) made by the outstanding shoemaker Yohei Fukuda. He had in fact trained at Cleverley before returning to Tokyo and starting his own bespoke business.

George showed me the room where they kept all the customer lasts – too many famous names to mention. George pointed out my last, hanging up alongside Terence Stamp and the Rolling Stones drummer Charlie Watts. I was indeed in esteemed company.

By the way, I still polish my shoes on a Sunday evening.

Watches
時計

私が最初にまともな時計を買ったのは、おそらく20年以上前のことだ。それはハンサムな〝IWC〟Mark XV のパイロット・ウォッチだった。ミリタリー的含蓄が好きだったのだ。シンプルなブラックの文字盤で、数字も明瞭にレイアウトされていた。ナンセンスな部分は全くない、毎日着用するのに適した時計だった。

それ以来、数多くの時計を買ったが、ほとんどは中古（セカンドハンド）のものだ（私が愉快に思うのは、ほとんどの時計ディーラーはこうした時計に対して「プリ・オウンド」、以前に所有されていたものという意味合いの言葉を使うことだ。この場合、最終的に適当な言葉は「中古」である）。しばらくの間、私は大きなケースの時計に魅かれていて、〝パネライ〟を所有していた。当

It must have been about 20 years ago that I bought my first proper watch, a handsome IWC Mark XV Pilot's watch. I liked its military connotations, the simple black dial and clearly laid-out numerals; it was a no-nonsense, everyday watch.

Since then, I have bought a number of watches, mostly second-hand. (It amuses me that most watch dealers refer to them as being pre-owned; second-hand, in this case, seems entirely appropriate.) For a while, I flirted with larger-cased watches, and I owned a Panerai, which at the time was a monster of a watch. But what niggled me about it was that I found

時は時計のモンスターだったが、ささいなことが気になった。磨かれたスティールのケースが光りすぎて、ミリタリーという外見と不釣り合いな感じがした。それで表面の仕上げを取り除き、全体がもっとインダストリアルな感じになるようにした。

こうしてみると、私は時計には率直で目的に沿ったもの、信頼性を求めている。おそらく、ほとんどのカソリックを信じる（権威主義の）男の嗜好には相反するかもしれないが、男のためのグラマラス・ウォッチというアイデアには戦慄を覚えるし、ダイヤモンドをちりばめたケースは下品の極みにさえ感じる。グラマーという単語は、私にとって映画女優を思い起こさせるのだ。私は決してあの日を忘れないだろう。1970年代にさかのぼって、サヴィル・ロウで働いていた頃、ローレン・バコールが店にやってきた。エレガントに足を組んで座り、髪をかきあげて、長く細いタバコに火をつけた。それからユニークで蠱惑的なあの声で、彼女の息子がオーバーコートを探していると告げたのだった。それがグラマー（魅力）だ。これで読者にも、私がグラマーという言葉と男を結びつけるのが難しいことは理解していただけたことだろう。

そういえば、サヴィル・ロウで起きた別の事件を思い出した。ある日、とても背が高く、純白のゆるやかなローブを着たもの憂げなナイジェリア人の紳士が、ダークスーツを着た頑健な従僕二人と一緒に店にやってきた。支払いの段階になって、私は彼の時計に気がついた。私が驚嘆したのは、それがケースはプラチナで、文字盤にはダイヤモンドが撒き散らされ、ピンボール・マシーンの渦巻き模様のようになっていたことだ。彼の手首の動きにつれて、ダイヤモンドが輝いていた。

the polished steel case to be too shiny and at odds with its otherwise military appearance. So I had the finish removed, to give it an altogether more industrial feel.

On the whole, I want my watches to be straightforward, purposeful and reliable. Not perhaps being a man of the most catholic tastes, I am filled with horror at the idea of glamorous watches for men; the thought of diamond-encrusted cases strikes me as the height of vulgarity. The word glamour, for me, conjures up images of female movie stars. I'll never forget the day back in the Seventies when I worked on Savile Row, when Lauren Bacall swept in, sat down, elegantly crossed her legs, tossed her hair, lit up a long, thin cigarette and in her uniquely seductive voice announced that her son needed an overcoat. That was glamour. So you'll understand when I say that I find it difficult to associate glamour with men.

That said, another Savile Row incident comes to mind. One day a very tall and languid Nigerian gentleman, in pristine white flowing robes and flanked by two burly dark-suited flunkeys, came into the shop. When the time came for him to pay for his purchases, I noticed his watch. I was mesmerised. It had a platinum case, and scattered across the dial were diamonds, like marbles in a

Ulysse Nardin second hand 1990s

Your cufflinks should match your watch in this case also the crown

1960s Tag Heuer

1963 Rolex Explorer inherited

Bremont made in England and founded by two brothers who's surname is English

Black Ceramic case I.W.C

Customised Cartier Tank.

1963 I.W.C. Bought in the market.

後にわかったのだが、彼はダイヤモンドのディーラーということだった。疑いもなく、彼にとってダイヤモンドは二束三文なのだろう。それならば、ちょっと楽しんでもいいのではないか？

私が思い出すのは父の控えめな時計だった。ダイアルには17ジュエル（宝石）の表記があったが、それらの宝石はどこにあるのか？ おそらく表から見ることはできないが、メカニズムのどこかにあるのだろう。昨今の自分を誇示する消費傾向によれば、グラマラス・ウォッチは闇社会で生きる者に、彼らの不正所得を誇示する完璧な機会を与えている。発展途上国の独裁者たちはグラマラス・ウォッチを購入する候補者たり得るだろう。中年の太鼓腹をしたタックス・ヘイブン（租税回避地）の居住者たちは、メガヨットの上で〝スピードー〟の水着一枚になったとき、手首にダイヤモンドが敷き詰められた時計があることで安心するに違いない。彼らの神々はありふれたダイバーズ・ウォッチのような時計は禁じているからだ。浜辺から眺めるぼんやりした旅行者にとって、彼らが海に浮かぶ巨大なエゴの塊のオーナーだと知らせ、単なるヨットのクルーだと間違えないようにするシグナルでもある。

私が所有している唯一の時計でグラマラスの部類に入るのはゴールドの〝カルティエ〟のタンクだ。これはグラマラスな場面の時だけ着けるようにしている。気まぐれなファッションを超越した完璧なドレスウォッチであり、純粋なシンプリシティと洗練された美しさに魅了されて購入したものだ。先日、アムステルダムからの帰りのフライトで、一人の男が通路の向こうからじっと私を見ていた。彼はついに勇気を奮い起こし、こう言った。「良い時計をしてらっしゃいますね」

pinball machine. As his wrist moved, so did the diamonds. I discovered later that he was a diamond dealer. No doubt to him diamonds were ten a penny, so why not have a bit of fun with them?

I am reminded of my father's modest watch, whose dial proclaimed its 17 jewels. Where were these jewels? Presumably somewhere in the mechanism, hidden from view. In today's climate of conspicuous consumption, glamorous watches give shady fellows the perfect opportunity to flaunt their ill-gotten gains. Despots in developing countries are likely candidates for glamorous watches, as is the middle-aged pot-bellied tax-haven resident who, when stripped down to his Speedos on his mega-yacht, must be reassured by a diamond-encrusted watch strapped to his wrist. Heaven forbid that this should be anything as mundane as a diver's watch. It's also a signal to any gawking tourists in the harbour that he is the owner of this mega floating ego, and is not to be mistaken for a mere deckhand. The only watch I own that could come under the heading glamorous is my gold Cartier Tank, which I only wear on glamorous occasions. I am attracted by its pure simplicity and refinement, which make it the perfect dress watch. It is beyond the vagaries of fashion. The other day, I was on a flight back from

Hackett Tag Heuer
collaboration
Limited Edition

奇抜な口説き文句だとその時は思ったが、それが1963年の〝ローレックス〟エクスプローラーだと彼に説明した。フライトの間、我々は時計のことを話して過ごした（訊かれる前に答えるが、いや、電話番号は交換しなかった）。いつも驚かされるのは実に多くの人がこの時計に対して好意的なコメントを寄せることだ。この時計は思慮深く、控えめであり、この時計の良さにここまで気がつくことはないだろうと思っていた。

人々が注意を払わないことに関して言えば、そのとき私はピッティ・イマジネ・ウオモ(注1)の会場にいた。ピッティは実際のところ、自分を見せびらかすためのイベントとなっていて、会場にいる男たち全員が念入りに装いを凝らしている。私はそこで「サルトリアリスト」(注2)のフォトグラファー、スコット・シューマンに、彼のブログに掲載するためのポートレートを撮影されたのだった。ヘヴィーなグレーフランネルのスーツを着ていて、大きなフェイスのブラック・セラミックの〝IWC〟クロノグラフ（映画『トップガン』エディションではないが、類似した時計）を選んでいた。ハケットのソーシャルメディア担当者が、私がブログに掲載されていると教えてくれた。幾つかのコメントを読むと、ほとんどが時計に関するものだった。「大き過ぎる」「派手だ」「エレガントではない」「スーツにはドレスウォッチをつけるべき」などなど。幾つか優しいコメントもあったが、ひとつのコメントによって私は自信を取り戻した。「イカした時計だぜ、ブラザー」。

〝IWC〟は私が気に入っているブランドのひとつである。ある日、空港で飛行機が遅れ、ぶらぶらとウィンドウショッピングをしていた。空港の店は遅延を好むものだ。旅行者がその間に買い物に

Amsterdam and a man across the aisle kept staring at me. He finally plucked up the courage to say, 'That's a fine watch you're wearing' – a novel pick-up line, I thought. I explained it was a 1963 Rolex Explorer, and for the duration of the flight we talked watches. (And before you ask, no, we didn't exchange telephone numbers.) I am always surprised at the number of people who make favourable comments on this particular watch, which is so discreet and understated that I expect it to pass unnoticed.

Talking of unnoticed, I was once at the Pitti menswear show – actually 'show-off' is more indicative of the event, as all the men there were dressed to the nines – and I was photographed by The Sartorialist photographer Scott Schuman for his blog. I was wearing a heavy grey flannel suit, and I had chosen to accessorize it with a large black ceramic IWC chronograph – not the Top Gun edition, but similar. Our social media people at Hackett pointed the blog out to me. I read some of the comments, which were mostly about my choice of watch. 'Too big', 'ostentatious', 'not elegant', 'should be a dress watch with a suit': these were some of the kinder remarks... Although I was heartened by one comment: 'wicked watch, bruv'.

IWC is one of my favoured brands. Once, when I was delayed at the airport,

行くからである。彼らはとてもチャーミングにその時間を「滞留時間」と呼んでいる。私といえば、"IWC"の店にぶらりと立ち寄ったつもりだったが、ついには多大なる苦悶の末に、ポルトギーゼ・クロノグラフを買う決断をした。いつもの私らしくないのだが、アイボリーの文字盤のものだ。ネイビーのクロコダイルのストラップが付いていたが、私には豪華すぎる感じがした。ここで控え目に見せるべくNATOベルトのネイビーとイエローのストラップに交換した。

今日の『タイムズ』紙には、"ローレックス"スピードキングの発見に関する記事が掲載されていた。英国空軍の士官所有の時計で、彼はスタラグ・ルフトⅢ（第三航空兵捕虜収容所、映画『大脱走』のモデルとなった、第二次世界大戦中のドイツ空軍の捕虜収容所）からの生存者だ。その時計はオークションにかけられるとのことだった。もし私がこの時計を所有できたら、どんなに素晴らしいことだろう。この時計は豊かなヘリテージとストーリーを持っている。この先何年もディナーパーティーの席で友人たちを楽しませてくれることだろう。私にとっては、これこそがグラマラスなのだ。

I wandered around window-shopping. Airport shops love delays; it means travelers go shopping. The call it, very charmingly, 'dwell time'. I dropped into the IWC shop, and after much agonising, I decided to buy a Portugieser Chronograph – unusually for me, one with an ivory dial. It came with a navy crocodile strap, which for me was just too extravagant, so I took it down a notch or two and replaced the strap with a NATO webbing navy-and-yellow-striped strap.

Only today in The Times there was a moving article about the discovery of a Rolex Speedking that had been owned by an RAF officer who was a survivor of Stalag Luft III, the Second World War concentration camp from the film The Great Escape. The watch was due to be auctioned. It occurred to me how wonderful it would be to own a watch with such a rich heritage, and a story with which I could regale friends at dinner parties for years to come. Now that's what I call glamorous.

(注1) ピッティ・イマジネ・ウオモはイタリアのフィレンツェで年2回開催されるメンズファッションの世界最大の展示会。
(注2) サルトリアリストはストリートファッションを撮影した世界で最も有名なブログのひとつ。アメリカ人のフォトグラファー、スコット・シューマン氏によって撮影、運営されている。

Fox Brothers & Flannel
〝フォックス・ブラザーズ〟とフランネル

1970年代の前期、私はサヴィル・ロウにあった〝ジョン・マイケル〟という会社で働いていた。そこで生地の片付けをしていたとき、〝フォックス・ブラザーズ〟という一つのラベルに遭遇した。クリーム・クリケット・フランネルという生地に心を奪われて、テーラーにその生地でオックスフォード・バグスを作ってくれないかと頼んだ（それは70年代のことだったのだ）。

私の初めてのフランネルの体験は良くないものだった。制服のズボン（トラウザーズ）はこのファブリックを使っていたが、それは硬くて、チクチクしていた。しかし、このクリームフランネルは何か完全に違うもので、触った感じは柔らかいが、仕立てるのに適した固さもあった。

〝ジョン・マイケル〟で働いていた頃、当時流行っていた既製服の著名なメーカー〝サイモン・アッカーマン〟のフォックス・フランネルを使用したグレーフランネルのスーツを何とかして手に入れたいと思っていた。数ヵ月後、ついにサイズ38のスーツを手に入れた（そんな時代もあったのだ）。それは私に完璧なまでにぴったりだった。

1983年に初めて〝ハケット〟をオープンしたときは、セカンドハンド・クローズ（古着）だけを売っていた。ヴィンテージ・クローズのビジネスは大変楽しかったが、古着を売るビジネスを継続するのは困難だという結論にすぐに達した。それで1986年にサヴィル・ロウ・スタイルにアイデアを得たクロージング・ラインを始めたのだった。

それはクラシックで、テーラードに焦点をあてたものだったので、サヴィル・ロウにファブリックを供給している多くのミル（紡績工場＆服地メーカー）を探し出した。スコットランドからツイードを、ウースティッド・ウールはハッダース

In the early 1970s I worked in Savile Row for a firm called John Michael. One day, while I was tidying up the cloth patterns I came across one labeled Fox Bros. I was very taken by the cream cricket flannel and asked the tailor if he would make me up a pair of Oxford bags (it was the Seventies).

My first experience of flannel had not been good: my school trousers had been made from this material and they were stiff and scratchy. But the cream flannel was something completely different – soft to the touch and yet firm to handle.

During my time at John Michael I had always admired the ready-to-wear clothing by the renowned manufacturer of the time, Simon Ackerman, and I had coveted the grey flannel suits made using Fox flannel. After many months I was able to purchase one – size 38 regular (those were the days), and it fitted perfectly.

When I first opened Hackett in 1983 I was only selling second hand-clothes, and I very quickly came to the conclusion that while vintage clothes were great fun, it would be difficult to create an ongoing business. So I created a clothing line in 1986 inspired by Savile Row style.

The range was classic and tailored, and I sought out many of the mills that provided cloth to the Savile Row tailors.

Fox Brothers & Flannel

フィールドから、もちろん、サマーセットにある〝フォックス・ブラザーズ〟からウェスト・イングランド・フランネルも購入した。

　初めて〝フォックス〟を訪ねたときのことは鮮明に覚えている。数百年にも遡る膨大なアーカイブには圧倒された。彼らはフランネルで有名だったが、同様にジャケット用のラムズ・ウール、カバート・クロス、メルトンも製造していた。最近では市場の需要に合わせ、より軽量の生地を作るようになっている。彼らのフォックス・ツイストは特に良い生地だ。ライトウェイトで皺にならず、旅行に最適だ。何が〝フォックス〟をそこまで魅力的にしているかといえば、ミルで行われているすべての努力が、最上級の糸を探し、伝統的な製法で織り上げるため、それが最終的に製品に表れていることだろう。

　2008年のある日、ダグラス・コルドー（現在の〝フォックス・ブラザーズ〟の共同経営者）とランチしていたときのことだ。当時、彼は〝ペペ・ジーンズ〟のクリエイティブ・ディレクターの職を離れたばかりだった。彼は自分自身がてこ入れできるブリティッシュ・ブランドを探しているのだという。

　幾つかのブランドの名が挙がった。その中で〝フォックス・ブラザーズ〟は経営上問題があると聞いたが、彼にとって興味深い案件になるかもしれないと提案した。

　〝フォックス〟はウィンストン・チャーチル、ケイリー・グラント、フレッド・アステアなど多くの著名人が着用し、他では代え難いヘリテージを持っているとダグラスに言った。その名は敬意をもって人々に迎えられている。もし破産したら、私はどこでフランネルを買えばよいのだろう、と。

I bought tweed from Scotland, worsted material from Huddersfield, and of course West of England flannel from Fox Brothers in Somerset.

I vividly remember my first visit to Fox, and being overwhelmed by their huge archives, which date back several hundred years. While they are famous for flannel, they also manufacture lambswool jacketing, covert cloth, and Melton. More recently, as the market has demanded, they have moved into making lighter-weight cloths – their Fox Twist is particularly good: lightweight and wrinkle-free, perfect for travelling. What makes Fox flannel so desirable is that every effort is made by the mill to source the finest yarns, and the cloth is milled in the traditional way, which is a laborious affair but adds so much to the finished fabric.

One day in 2008 over lunch, Douglas Cordeaux (the current owner of Fox), who had recently left his position as creative director at Pepe Jeans, explained to me that he was looking for a British brand to develop.

We threw a few names around and I made the suggestion to him that Fox Brothers could be an interesting proposition, as I had heard they were experiencing problems. I said it has an unassailable heritage, Fox cloth having

偶然にも、ダグラスは〝フォックス〟のすぐ近くに住んでいた。彼の経営上のパトーナー、デボラ・ミーデン（英国のTV番組「ドラゴンズ・デン」で有名な投資家であり、サマーセット在住）と共に調査のためにミルを訪問し、〝フォックス〟が衰退の一途を辿っていたにもかかわらず、すっかり心を奪われてしまった。彼らは即座にかつての栄光を復活させる可能性を見出したのだ。

今では〝フォックス・ブラザーズ〟はビジネスが軌道に乗り、スタッフも増え、新しい機械も導入、世界中のベスト・ファッションハウスと取引を開始したことは本当に喜ばしい。そして何より、最も重要なことは、どこで私のフランネルを買えばいいのか、その心配が無くなったことである。

been worn by Winston Churchill, Cary Grant and Fred Astaire, to name a few. It's a well-respected name, and if it goes under, where am I going to buy my flannel?

It so happened that Douglas lived very close to Fox Brothers. With his partner Deborah Meaden (of Dragons' Den fame, who also lived in Somerset), they made an exploratory visit to the mill and were captivated, despite the fact that it was pretty run down. They immediately saw the potential to restore it to its former glory.

Diary of a somebody

ある男のダイアリー

Day 1

デザイナー、ロンドン・コレクションに
向けて行動開始

　長過ぎたクリスマス・ホリデーから日常の緊張へ戻るのは非常に喜ばしい。ロンドン・コレクションと共に熱狂的な一週間が始まる。手始めは金曜日の夜で、2015年秋冬のカプセル・コレクションを披露するのだ。

　グレーのどんよりとしたストックウェルの朝、サセックス・スパニエルのマフィンは朝の散歩を忍耐強く待っていた。犬の散歩係が無断欠勤したので、私に選択肢はなかった。マフィンを連れて、

Day 1

The designer swings into action
ahead of the London collections

I'm very pleased to be back in the fray after a too-long Christmas break. A hectic week beckons, with London Collections: Men kicking off on Friday evening, when I'll be showing a capsule collection for autumn/winter 2015.

It's a grey, damp morning in Stockwell and my Sussex spaniel, Muffin, is patiently waiting for her morning walk.

ショーのためのサンプルが到着したオフィスへ向かう。いつも爪をかむようなイライラした気分になる瞬間だ。すべて間違いはないだろうか？ メーカーは私の指示通りに作ってきただろうか？

幾つかのものがまだ到着していなかったが、明日には届くだろうと確信していた。シャツはどこにあるのだろう？ ニットウェアは郵送中で、バッグはこちらに向かっている最中だ。

よく準備したつもりでも、最後にパニックになることはよくある。招待状は発送され、もう後戻りはできない。だがよく言われるように、最後はすべてがうまくいくものだ。そう願いたい。

スローン・ストリート店に週一回の訪問に行く。いつもひとつ、ふたつの店舗は訪れるようにしている。セールスはどうなっているか、スタッフと話をするためである。オフィスのコンピューターの数字を眺めているよりも、店のフロアにいる方が、ビジネスについて多くを学ぶことができる。

ここで、まだ新しいダイアリーを買っていないことを思い出した。隣のステーショナリーの老舗〝スマイソン〟へ行き、フェザーライト・パナマ・ダイアリーを選ぶ。ここでダイアリーを買う習慣を20年以上続けているが、いつもネイビーブルーを選んできた。モノグラムを入れてくれるよう頼んで待っていると、非常にありがたいことに、約30分で出来上がってきた（30分といえば、道の向こうにある〝ピッコロ・バー〟でサンドイッチをつまむのにちょうど良い時間だ。読者も見てお分かりの通り、常にスマートなレストランでグラマラスなランチをしているわけではないのである）。

帰宅すると、私の持っている1995年版のダイアリーと何か変わったところはないか、過去の

My dog-walker has gone awol so it's down to me. With Muffin in tow I head off to the office, where I check the arrival of samples for the show. It's always a nail-biting moment. Are they correct? Did the manufacturers follow my instructions?

Several pieces are yet to arrive but I am assured they will be with me tomorrow. Where are the shirts? A couple of pieces of knitwear are apparently in the post; the bags are on their way.

It seems that however well prepared you are it always ends up being a last-minute panic. The invitations have gone out so there's no turning back – but, as they say, it will be all right on the night. I do hope so.

Off to our Sloane Street store for my weekly visit. I always try to take in a shop or two, just to get a feel for how our sales are going and to chat to the staff. I find that I learn more about the business by being on the shop floor than staring at numbers on a computer in the office.

I remember that I have yet to buy a new diary, so I pop next door to Smythson and pick up one of their featherweight Panama diaries – something I've done for more than 20 years, always in navy blue. I ask them to monogram it while I wait and, very obligingly, it is ready within half an hour (giving me just enough time to grab a sandwich at the Piccolo Bar across the road; as you can see, it's not all glamorous

ものと比べてみた。私は磨きこまれたオーク製のミニチュアのベンチに、すべてのダイアリーを保管している。それも〝スマイソン〟で作られたものだ。アーツ&クラフトのスタイルで、おそらく1900年ごろに作られたものだろう。喜ばしいことに、新旧のダイアリーにはほとんど変化はなかった。

　午後はいろいろな国の出版社への返答に時間を費やした。出版社はいつも類似したテーマを追っている。あなたの洋服は誰に着てほしいですか？〝ハケット〟に有名な顧客はいますか？あなたが思う最もスタイリッシュな人物は？といったものだ。

　私のブログ「Mr Classic」の下書きをする。突然、友人からeメールが来て、彼とガールフレンドがディナーに来ることを思い出した。もはや完全に忘れていたので、地元のインディアンレストラン〝ホット・スタッフ〟からのテイク・アウェイ（持ち帰り）となったが、なかなか良かった。

　マフィンはドアのところで待っていて、散歩を要求している。それはお互いにとってもいいものだ。その後、家に戻ってから、ファッション・ショーのために頼み忘れたものがある気がして、そのことが頭から離れなかった。願わくば、朝までに思いだしますように。夜の間に思い出した時のために、新しい〝スマイソン〟のダイアリーをベッドサイドに置いた。

lunches in smart restaurants).

　Back home I am interested to see if there is any difference between my 1995 Smythson diary and the one I have just bought. I keep all my diaries on a polished miniature oak bench, also made by Smythson, in the Arts & Crafts style, and probably produced around 1900. Pleasingly there is barely any difference between old and new.

　I spend the afternoon answering questions for various international publications, which invariably follow similar themes: Who would you like to dress? Do you have any famous customers? Who is the most stylish man? And so on.

　I write a draft for my blog, Mr Classic. Suddenly an email pops up from a friend reminding me that he and his girlfriend are coming over for dinner. I had completely forgotten, so it looks like a takeaway from my local Indian restaurant Hot Stuff, which is actually rather good.

　Muffin is waiting at the door, demanding to be taken for a walk, which is good for both of us. Later, as I turn in, I can't help thinking there's something I have forgotten to order for the fashion show. Hopefully I'll remember by morning. My new Smythson diary is by my bedside in case it comes to me during the night.

Day 2

ファッション・ウィークの準備中、
〝ハケット〟の創業者、ペットの
マフィンに集中する

　12月28日以来、一滴のアルコールにも触れていない（忙しくなる前に、新年の抱負を早めに実行するのが好きなのだ）。非常にいい気分だ。幾らか体重が減っていることを期待して、まず体重計に乗ってみる。全く意気消沈することには、なんと数ポンド増えているではないか。さあマフィン、おいで。活気溢れる散歩の時間だ。

　朝のお茶と一緒に熟読する『ザ・タイムズ』紙を取り上げると、ベルトについて書いた記事を読んだ。私はしばしば面白いと思った新聞の話をスクラップして保管し、ブログに使うことがある。この特殊なベルトは新しい発明で、ウェストラインをモニターし、それに応じて直してくれるらしい。流行り物で名前は「ベルティ」、昨年大流行した「ワンジー（上下繋がったジャンプスーツ）」のようなものか。

　昨日、1995年の私の〝スマイソン〟のダイアリーをパラパラ見ていたら、一枚の紙が滑り落ちた。それは新聞の切り抜きで、「本日の感想」と題したアメリカの作家ヘンリー・デイヴィッド・ソローの引用が書かれていた。「新しい服を要求するような会社にはことごとく気をつけよ」。純粋なブリティッシュ・ファッションの定義では、誰かが私の新しいスーツに気がついたら、私はこう言うだろう、「この古いスーツかい？　もう何年も着ているよ」（数年前に、母が『オックスフォード引用句辞典』を送ってくれた。何か書くときに、

Day 2

Between fashion-week prep,
the Hackett founder focuses on
a mate for Muffin

　Not having touched a drop of alcohol since December 28 (I like to start my New Year's resolutions early, before the rush) and feeling quite smug, the first thing I do is jump on the scales, anticipating some weight loss. To my utter dismay, I discover that in fact I have gained several pounds. So come on, Muffin – it's time for a brisk walk.

　I pick up a copy of The Times, which I peruse with my morning tea, and alight on a story about belts. I often tear stories out of the paper that amuse me and file them away to use in my blog. It seems this particular belt is a new invention and one that monitors your waistline and alters it accordingly. As is the vogue, it is called a Belty, just as last year was all about the onesie.

　Yesterday, when I was flicking through my 1995 Smythson diary, a slip of paper dropped out. It was a newspaper cutting headed 'Thought for the Day' with a quote from the American writer Henry David Thoreau: 'Beware of all enterprises that require new clothes'. So, in true British fashion, when someone remarks on my new suit I shall say, 'This old thing? I've had

普段、人々が目にしないような引用を入れると、実際よりもよく聞こえるものだと教えてくれた。母に感謝だ）。

ニューボンド・ストリートにあるショールームで打ち合わせをする。私が到着したとき、そこは活気に溢れていた。来週、世界中からやってくる卸売業者に向けたメイン・コレクションの準備の最中だった。これはいつもエキサイティングな時間で、開梱された箱からは秋物の新製品が見えている。

金曜日のディナーの席の配置と出席者について、PR（広報）と短いミーティングをする。今のところ、順調のようだ。

通り過ぎた無数のアート・ギャラリーからの文化的な刺激を楽しみながら、ボンド・ストリートを散策。私の方に向かって歩いてくるご婦人がマフィンと私を訝しげに見ている。次に、彼女が「あなたはもしや？」と私に訊いてくるのが直感的にわかった。私はこう答える。「そうです、ジェレミー・ハケットです」と。それから彼女はマフィンを見ると、感極まったように「これがあのマフィン！」と叫んだ。

少しムッとしたのは、ジャーミン・ストリートにあるイタリアン・レストラン、フランコズに着くのを心配していたからだ。ひとりのスポンサーとランチをする予定だった。フランコズでは犬を歓迎していると判明して以来、そこで定期的に食事をするようになった。フランコズは料理そのものもなかなかいい。ブリティッシュ・アーミー・ポロのチームを率いるマーク・カーンに会った。彼とは長い付き合いだ。テーブルに着くと、マフィンは既にテーブルのしたで眠りに落ちていた。ポロについて簡潔なディスカッションを交わすと、

it for years'. (Many years ago, my mother sent me a copy of the Oxford Dictionary of Quotations and said that when writing something, dropping in the odd quotation will make you appear much better read than you actually are. Thanks, Mum.)

I have an appointment at our showroom in New Bond Street. When I arrive it's a hive of activity, as preparations are made to show the main collection to our wholesale customers, who will descend on us from around the world next week. It is always an exciting time, as boxes are unpacked revealing all the new products for autumn.

I have a brief meeting with our PR, who updates me on the seating plan for Friday's dinner and confirms who is attending; so far it looks like a pretty good turn-out.

I stroll down Bond Street enjoying a culture hit from the numerous art galleries I pass. A lady is walking towards me, looking at Muffin and me quizzically. I sense she is about to ask, 'Are you..?' And I'm ready to say, 'Well yes, I am Jeremy Hackett.' At which point she looks at Muffin and exclaims, 'That's Muffin!'

Feeling a bit miffed I am now anxious to reach Franco's in Jermyn Street, where I have arranged to have lunch with one of our partners. Ever since I discovered that dogs are welcome, I have dined at

その日のランチの本題に入る。マフィンの相手探しだ。サセックス・スパニエルは絶滅犬種のリストにあり、サセックス・スパニエル組合のパトロンとして、この品種の育成にベストを尽くすことが私にできる唯一の使命に思われた。マフィンをとても気にいっているマークは、寛大にも彼女が妊娠した暁には面倒を見ると約束してくれた。これで残ったのは、マフィンに最適のパートナーを見つけることだけだ。

　私をオールド・ストリートに連れていくタクシーは6時30分に到着した。そこではモデルが金曜日のショーに向けてフィッティングをしている。長い夜になりそうだ。

Day 3

モデルたち、衣装の紛失、問題のある配置表、メンズウェアデザイナーにとって大事な一夜

　私がその晩、何をしたかについてお話しすることにしよう。タクシードライバーは6時30分きっかりに到着し、私をロンドンの繁華街イースト・エンドへと連れ去った。予定した場所に着いたとき、ちょっとした問題が起こった。ドライバー

Franco's regularly; the food's not bad either. I meet Mark Caan, who heads up British Army Polo and with whom we have enjoyed a long association. Settled at our table, with Muffin already asleep underneath, we briefly discuss polo and then get down to the real reason for our lunch, which is to organise the mating of Muffin. Sussex Spaniels are on the endangered list and as patron of the Sussex Spaniel Association I feel it is only right that I do my best to further the growth of the breed. Mark, who is very taken with Muffin, generously agrees to assume responsibility for her care throughout her pregnancy. It only remains for me to find her a suitable partner.

　A cab arrives at 6.30pm to take me to Old Street, where models arrive for fittings ahead of Friday's show. It is likely to be a long night...

Day 3

Models, missing outfits and a problematic placement make for an absorbing evening for the menswear designer

　Let me tell you about my evening. My taxi arrived on the dot of 6.30pm and whisked me off to the East End. But when the cab arrived at the designated destination there was a slight problem –

も私もスタジオの番地を知らなかったのだ。私はタクシーから流行の先端を気取ったヒップスターでいっぱいの荒野に放り出された。全くの場違いだった。酔っ払いで溢れた通りを覗き込むと、若い男の集団が倉庫から出てきたのに気がついた。その髪を振り乱した様子を見て、彼らはモデルだと確信した。

　幸運にも、私の勘は当たっていた。その場所は人々のざわめきでいっぱいで、モデルは階段で列を作っていた。こうして私はスタジオへ行き着いた。いつも私が驚くのは、ほんの数分のショーにいかに多くの人が係わっているかということだ。私のPRチームもそこにいて、マーケティング・ガールズも一緒だった。アシスタントと一緒にスタイリスト、数人のお針子たち、フォトグラファー、フォトグラファーのアシスタント、そして最も重要なティー・メイカー（お茶の係）もいた。PRチームはまだ配席表に苦しんでおり、すべての問題はそこから起きているようだった。「この二人は一緒にすべきじゃない、仲が悪くてお互いに一緒の場にいるのが耐えられないから。そのジャーナリストの隣にこの雑誌の編集者はまずいんじゃないかしら。彼女が彼を先週クビにしたばかりだから」などなど。だが、彼らが最終的には事態を解決することはわかっていた。誰もが1～2杯のシャンパンを飲めば、気分がよくなるものだからだ。

　一方、私のマーケティング・アシスタントはサプライヤーと熱い議論を交わしていた。その日に商品の到着を約束していたのに、サプライヤーは約束を守れなかったのだ。すべての衣装をスタイリストとチェックして、3つ足りないものがあるのに気がついた。「明日、必ず」、これを聞いてと

neither the driver nor I knew the number of the studio. So I was dumped in the middle of hipsterland, and because I wasn't sporting a beard I stuck out like a sore thumb. Peering down the badly lit street I noticed a gaggle of young men leaving a warehouse and felt sure they had to be models, judging by their dishevelled appearance.

Fortunately, I was on the money. Inside, the place was buzzing and models were waiting in line on the staircase as I made my way up to the studio. It always surprises me how many people are involved in putting on a fashion show that only lasts a matter of minutes. My PR team were there, as were the marketing girls; there was a stylist with an assistant; a couple of seamstresses; a photographer; a photographer's assistant; the production team; and – most importantly – a tea-maker. The PR team were still agonising over the seating plan, which appeared to be causing them all sorts of problems. 'We can't seat so-and-so together because they can't stand the sight of each other. It's probably not a good idea to put that journalist next to that magazine editor because she fired him last week…' and so it went on. I'm sure they'll get it sorted; everyone will get on famously once they've had a glass of bubbly or two.

My marketing assistant was having a

Muffin receiving her show instructions

りあえず安心したが、この言葉は以前どこかで聞いたことはないか？

モデルを選ぶのは簡単な仕事ではない。ロンドンの真ん中でフラフラになるまで歩かされ、呼ばれるまで忍耐強く待っても、あらゆる理由で選考から落とされる。背が高すぎる、低すぎる、刺青が目立ちすぎ、髪がイメージと合ってない。リストは果てしなく続く。しかし、その晩はモデル全員が顔見知りだったようで、それ自体がソーシャルイベントのようだった。いちどモデルを選抜した短いリストを作ると、それぞれの衣装に最も合うモデルを決め、お針子が彼らのボディサイズに合わせて最終調整をする。ジャケットやトラウザーズの調整、ひとりのモデルが肩を落としたので、袖を短かくしたりした（誰もが完璧な体型ではない、モデルでさえもだ）。

どのアンサンブルにどのアクセサリー（帽子やタイなどのこと）を合わせるか。この組み合わせを考えるのは大変楽しい作業だ。帽子はこう、スカーフはこうといった具合だ。この格好はやり過ぎだと思うか？　など、試行錯誤する。その日の夕方、私は屋根裏からシープスキンのフラップがついたヴィンテージの茶色のボウラーハットを持ってきた。何年も忘れ去られて屋根裏にあったものだ。この帽子に対する一般的な反応はどうだろうか？　この帽子を使いたいと思ったのは、かつて古着を売っていた〝ハケット〟のルーツに言及したいと思ったからだった。それがすべての始まりだった。サヴィル・ロウのテーラー、バーナード・ウェザリルが彼のバックグラウンドに基づいて、ウェストコートのポケットに裁縫用の指ぬきを配したように。

ようやくモデルが衣装を身につけて、写真撮

heated discussion with a supplier who had promised a delivery that day and it hadn't turned up. I then went through all the outfits with the stylist, and realised that three were missing. 'Tomorrow,' I was assured. Now where had I heard that before?

It's no easy task choosing models, and one feels for them when they've made the effort to traipse halfway across London and wait patiently to be called, only to be rejected for any number of reasons – too big, too short, too many visible tattoos, the wrong sort of hair. The list goes on. But they all seemed to know each other, and the evening became a social event in itself. Once we had made the shortlist, we decided who looked best in each outfit and the seamstress attended to the finishing touches, which could include taking in a jacket or trousers, or shortening a sleeve because the model drops on one shoulder (nobody's perfect, not even models).

We had great fun deciding how to accessorise each ensemble – a hat here, a scarf there. Do you think that looks too much? What was the general opinion of a vintage brown bowler with sheepskin flaps that earlier in the evening I had rescued from my attic, where it had lain forgotten for years? I just thought I'd like to reference the Hackett roots and where it all started – selling second-hand clothes. Rather like Savile Row tailor Bernard

影を行った。彼らが問題なく歩けるかどうかをチェックする。キャットウォーク・ショーは非常に重要である。すべてのチェックを終えると、私たち全員がリラックスして、軽食をつまみ、ワインを飲んだ。新年の抱負を実行して以来、9日間でこれが最初のワインだ。

　今朝、もう一度体重を測ると、3ポンド（約1.4kg）の減量に成功していたので、爽快な気分になった。これからはワインダイエットに励むこととしよう。

Day 4

デザイナー、ファッション・ショーが
シープ・シェイプ（きちんと用意されていること）
であると確認

　いよいよビッグ・デイの前日となった。最後の準備に取り掛かる。まず会場へ行き、製作のディレクターと会った。少し前に訪問していたが、もう一度部屋を見て、レイアウトを確認したかったのだ。ディナーとファッション・ショーはヴィクトリア・エンバンクメント（ロンドンのテムズ河沿岸のエリア）に隣接したツー・テンプル・プレイスと呼ばれる素晴らしい屋敷で開催された。ヴィクトリア時代後期の屋敷（マンション）で、世界で最も富裕な男、ウィリアム・ウォルドルフ・アスターの注文を受け、モダン＝ゴシック様式で建築されたものだ。彼は自らのエキセントリックでロマンティックな家の建築に費用を惜しまなかった。ここには最もドラマティックなセッティ

Weatherill, who, to remind himself of his background, carried a thimble in his waistcoat pocket.

　Finally, after all the models had been dressed, photographed – and checked to see that they could walk properly, which for a catwalk show is pretty important – we all relaxed and had a bite to eat and a glass of wine: my first for nine days.

　Weighing myself again this morning I am thrilled to see that I have lost three pounds. I am definitely going on the wine diet.

Day 4

The designer makes sure his fashion show is sheep shape

　It's the day before the big day and I spend it making final preparations. I meet the director of production at the venue first thing; although I visited a while ago, I want to check out the room and its layout. The dinner and fashion show are taking place at a wonderful house adjacent to Victoria Embankment called Two Temple Place. It's a late-Victorian mansion built in the modern-Gothic style and commissioned by the then-richest man in the world, William Waldorf Astor. No expense was spared in creating his eccentric and romantic home. It will provide a most dramatic setting.

ングが用意されている。

　ショーのための音楽を選ぶ。ショーの製作にはこれも重要だ。ゆったりとした流れ、物憂げでスローな曲が欲しいと思った。キャットウォークでモデルが早く歩き過ぎるのを防ぐためだ。そこでブリティッシュ・アーティストのボノボを選んだ。数年前に聴いたもので、サーフィンの映画のサウンドトラックだったにちがいない。この音楽は今回のショーには完璧だろうと思った。

　オフィスに戻り、最後の仕上げにかかった。心配していたように、いくつか未だに無いものがある。残りわずか24時間となり、いくら控えめに言っても心配だ。

　私は英国服飾産業の熱心な応援者であることもあり、この産業を祝して、今回のショーを「シープ・シェイプ&ロンドン・ファッション」と呼ぶことにした。一時、英国は世界的に優れたウールの輸出者だったが、今ではほとんど工芸（クラフト）産業となってしまった。しかし、今でも英国はヨーロッパで最大の羊頭数を誇っている。羊毛産業が再生し、より商業的な足場が形成されることもあながち夢ではない。数年前にサマーセットにある〝フォックス・ブラザーズ〟を訪れた。私のお気に入りのミル（紡績工場&メーカー）のひとつで、200年以上の歴史を持つ素晴らしい紡毛のフランネルのメーカーだ。今回のショーのために彼らと提携し、すべてのスーツとジャケットが彼らの輝かしい伝説を持つファブリックから作られた。ミルの現在のオーナーはダグラス・コルドーと、TV番組「ドラゴンズ・デン」で有名なデボラ・ミーデンである（彼女は性格はいいが、いざ交渉になると俄然力を発揮する。そういうわけで、交渉の場に彼女がいたら、私の側についてもらい

　I choose the music for the show, which is an important part of the production. I want a piece with a gentle flow, something quite slow and languid to prevent the models walking the catwalk too quickly. I go for a piece by the British artist Bonobo. I heard it a while ago, on the soundtrack to a surfing film I believe, and I think it will be perfect.

　Back at the office we have a final run-through of the outfits. Worryingly a couple of pieces are still missing – with only 24 hours to go I am a little anxious to say the least.

　I have called the show 'Sheep Shape and London Fashion', to celebrate the British cloth industry, of which I am a passionate supporter. At one time Britain was the world's premium exporter of wool; today it is now pretty much a craft industry, but as Britain has the largest flocks of sheep in Europe it seems plausible that the wool industry could be rejuvenated and put on a more commercial footing. A few years ago I visited Fox Brothers in Somerset, one of my favourite mills and makers of fine woollen flannel for more than 200 years. I have collaborated with them for the show, and all the suits and jackets are made from their illustrious material. The mill's current owners are Douglas Cordeaux and Deborah Meaden, of Dragons' Den fame (who turns out to

たいものだ！）。私たちは真の英国産ウール再生の可能性について議論し、最終的に羊の群れに興味を持った。私はいつもカントリーサイドに家を持つ夢を持っていた。そこでは羊が草を食む、羊飼いさながらの光景を眺めることができる。まあ、家は持っていないにせよ、数匹の羊と土地をシェアすることはできる。まだ時期尚早だが、人々の手に英国産ウールを取り戻す、これには実現の可能性がある。

夜は、メンズ・ライフスタイル・マガジン『ザ・レイク』誌の発行者ウェイ・コーが主催したクラリッジズ（ホテル）のレセプション・パーティーに出席した。イベントは大盛況で、多くの顔馴染みと出会った。中には私の良い友人であり、『ハウ・ツー・スペンド・イット（いかにお金を使うべきか）』誌の寄稿者であり、編集者でもあるニック・フォークスもいた。彼は20年以上前に作った〝ハケット〟のスーツを着ているという。実際、そのスーツはとても格好良かったと言わねばならない。

モデルが何を着るかに時間を費やしていたので、そのショーの晩に自分自身が何を着るかは全く考えていなかった。恐らくネイビーブルーのテーラードスーツがどこかにあるはずだ。それを探して着ればいいだろう。

be a pussycat, although in any negotiation I would want her on my side of the table!). We discussed the possibility of reviving true British wool, and to that end we have taken a shared interest in a flock of sheep. I have always dreamed of owning a house in the country where I could gaze out at a pastoral scene of sheep grazing in parkland. Well, I don't have the house, but I do have a share in some sheep and a couple of fields. It's early days but I think there is a real opportunity to put British wool back on people's backs.

In the evening I attend a reception at Claridge's hosted by Wei Koh, publisher of men's lifestyle magazine 'The Rake'. The event is mobbed, and I run into many familiar faces, including my good friend and 'How To Spend It' contributing editor Nick Foulkes. He points out that he's wearing a Hackett suit we made for him more than 20 years ago – and I have to say, it looks very good.

Having spent a good deal of time on what the models will be wearing, I have given no thought to my own wardrobe for the evening of the show. I'll probably just dig out a navy blue tailored suit and be done.

Day 5

〝ハケット〟創業者による
ファッション・ショー、ロンドン・コレクション：
メン、大部分は問題なく終了

　ファッション・ショーの朝、早く起きた私はコンサヴァトリー（庭に面した温室）に座り、私の「ハウ・ツー・スペンド・イット（いかにお金を使ったか）」日記を書いていた。窓の外を一瞥すると、先日の朝見た狐が庭に戻って来て、こちらを凝視しているのに気がついた。今回のコレクションがすべて〝フォックス・ブラザーズ〟の服地から作られていることを考えると、これは良い前兆に思われた。

　私のPR（広報）はさまざまな媒体によるインタビューの最新スケジュールを送ってきた。午後1時から4時までの間に30分の休憩があった。急いで家に帰って着替え、ドレス・リハーサルをする会場に向かうのにちょうど間に合う時間だろう。今まで多くのインタビューを受けてきたが、私は常にジャーナリストが〝ハケット〟に対してどんなアプローチをし、どんな角度で物語を書くのか、非常に用心している。ときどき、いかなる理由にせよ、インタビューがうまくいかないだろうと感じることがある。彼らの中ではあらかじめブランドや私自身に対してのイメージができあがっており、その先入観念を変えようとするのは並大抵のことではない。また一方では、私が何時間も話すことができ、ランチでもしようとこちらから誘う気になるようなジャーナリストもいる（私のこの申し出により、PRチームは舞台裏でパニックとなる。インタビューの時間が足りなくな

Day 5

The Hackett founder's fashion show for London Collections: Men goes without a hitch… almost.

On the morning of the fashion show I'm up early and sitting in my conservatory, writing my 'How To Spend It' diary. I glance out of the window and notice the fox I'd seen the other morning is back in my garden, staring at me. I take it as a good omen, seeing as all the clothes in the show are made from Fox Brothers cloth.

My PR sends me an updated schedule of interviews with various publications. They are at half-hour intervals from 1pm until 4pm, leaving me just enough time afterwards to dash home and change before heading to the venue in time for the dress rehearsal. Despite having given many interviews, I am always a little wary as to how the journalist is going to approach a story about Hackett, and what their angle might be. Sometimes one will turn up and, for whatever reason, I can sense the interview isn't going to go well. It might be that they have a preconceived image of me or the brand, which I then see as a challenge and do my damnedest to change. Then there are journalists with whom I can chat for hours and really mean it when I say we must have lunch

るからだ)。だがその結果、しばしば私たちは良い友人となることもある。今日のインタビューはうまく行き、誰もが「シープ・シェイプ&ロンドン・ファッション」というコンセプトに魅了されたようだ。

この段階で、何を着るか、まだ決めていない。当初はネイビーの3ピース、チョークストライプのフランネルスーツを着るつもりだった(自然に服地は〝フォックス・ブラザーズ〟を選んだ)。だが、今日は予測していたのと天気が変わって、今は12℃の穏やかな気候だ。それでライトウェイトのネイビーの2ピースを選んだ。カクテル・パーティーに着用するお気に入りで、いわば男性版リトル・ブラック・ドレスといったものだ。マフィンは敏感に何かを感じ取り、俄然興奮している。シープスキンの首輪と、新しい縄のリードをつけ、キャットウォークの初登場に備えた。

ファッション・ショーが開かれた会場の巨大なダイニングルームは、テーブルの上に天蓋のように吊るした大きな裸木で装飾されていた。あたかも『不思議の国のアリス』の世界の雰囲気で、実に印象的に秋のテーブルを演出していた。また、各ゲストのテーブルにはハンカチーフが美しくセットされていた。そのハンカチには羊の頭を持つストライプスーツを着た男を描いた、私の小さないたずら書きをプリントしてあった。後でこのハンカチーフに数多くのゲストからサインを頼まれた。

午後7時までにモデル全員がリハーサルを終えた。私たちはヘアドレッサーが仕上げをしている間に、衣装に最後の調整を施した。ドレッシングルームでは全員が静かだったが、ゲストがカクテルのために到着し、階下から華やかなざわめきが

(while my PR in the background panics because we are running over the allotted time). Often we become great friends. As it turns out, today's interviews go well, as everyone seems fascinated by the concept of 'Sheep Shape and London Fashion'.

I still haven't decided what to wear. Initially I earmarked a navy three-piece chalk-stripe flannel suit (the cloth was made by Fox Brothers, naturally), but the temperature has changed and as it's now a balmy 12 degrees. So I opt for a lightweight navy two-piece – a favourite for cocktail parties and the men's equivalent of a little black dress. My dog Muffin, sensing something in the air, becomes quite excited. I have made her a sheepskin collar and new rope lead in readiness for her first appearance on the catwalk.

The huge dining room where the fashion show is to be held has been decorated with large bare branches that hang like canopies over the tables, creating a striking autumnal effect and an almost Alice in Wonderland atmosphere. The tables are beautifully set, with a handkerchief – printed with my little doodle of a man's body in a striped suit with a sheep's head – laid for each guest. Later, a number of guests ask me to I sign it.

By 7pm the models have all performed the last walk-through; we make final

聞こえてきた。係りの者が、ゲスト全員が到着し、席に着いたと合図を送ってきた。

　ショーはショートビデオのプレゼンテーションで開幕し、私は来場者に感謝を述べると、今回のコンセプトを説明した。自分自身をスクリーンで見るのは嫌だったが、私にはラジオ用の顔があった。以前、BBC（英国国営放送）でブラック・タイ（ディナー・スーツ）についてラジオ・インタビューの依頼があった。ラジオであったとしても、昔、新人のプレゼンターはブラック・タイを着用していた。それで私もブラック・タイを着て出演したら楽しいのではないかと思ったのだ。録音ブースに案内され、プロデューサーとスタッフがジーンズとTシャツを着ているのは本当にゾッとするというように装った。そのインタビューはとてもうまく行った。

　モデルが整列し、エントランスに立つと、もう一度、ゆっくりと歩くように頼んだ。ありがたいことには、メイン・コレクションから幾つか代用しなくてはならなかったにも関わらず、ショーは何の問題もなく成功裏に終わった。私が登場する番だ。あれだけモデルにはゆっくり歩けと言ったくせに、できるだけ早く終わるよう、急ぎ足でキャットウォークを歩いた。一方、マフィンは賛辞とスポットライトが当たった瞬間を大いに楽しんでいた。

　ディナーパーティーは大成功だった。数多くのセレブリティが出席したが、どのゲストも有名なスターだから、ここで名前を明かすことはしないでおこう。最後の一人が帰る頃には深夜となっていた。これは人々がパーティーを楽しんだ確かなサインだ。

　タクシーのシートの背にもたれかかると、マ

adjustments to their outfits while the hairdressers do the last bit of teasing. It is all calm in the dressing room, but we can hear escalating chatter downstairs as guests begin to arrive for drinks. A look-out has been placed to give us the signal that everyone has arrived and is seated.

We open with a short video presentation, in which I thank everyone for coming and briefly explain the concept. I loathe seeing myself on screen; I have a face for radio. I'm reminded that some time ago the BBC called me and asked if I could do a radio interview about black tie. I thought it would be amusing to turn up wearing it, reminiscent of the time when news presenters wore black tie, despite being on the radio. As I was ushered into the booth for the recording, I feigned absolute horror that the producer and sound people were dressed in jeans and T-shirts – it went down very well.

As the models stand in line ready to make their entrance, I ask them one more time to take it slowly. Thankfully it goes without a hitch, despite the fact we've had to substitute a couple of missing outfits with pieces from the main collection. I make my appearance. Disregarding everything I've said to the models about taking it slowly, I make a mad dash down the catwalk to get it over as quickly as possible. Muffin revels in the adulation

フィンは足元で眠りについていた。ヴォクソール・ブリッジに差し掛かり、窓の外を見ると、スマートなスーツを着こなした、素晴らしくウェルドレスな男二人が橋を渡っていくのが目に入った。私の幻想なのか、彼らはミステリアスな様子であんな格好で道に迷っているのだろうか？　たぶん、シャンパンを飲んだせいだろう。では、良い夢を。

and her moment in the spotlight.

The dinner party is a great success, and while there are a number of celebrities present, they shall remain nameless because as far as I'm concerned each of my distinguished guests is a star. It is midnight before the last one leaves, a sure sign that people have had a good time.

Slumped in the back of a cab with Muffin fast asleep at my feet, we make our way over Vauxhall Bridge. I look out of the window and spot two incredibly well-dressed guys in very smart suits strolling across the bridge. Is it my imagination or are they wearing the clothes that had mysteriously gone astray? Perhaps it's the champagne… Good night.

Dog Day Afternoon
ドッグ・デイ・アフタヌーン

20年前のある日の午後、バターシー・ドッグス＆キャッツ・ホームを通りかかった。一度も訪れたことはなかったのに、ふいに訪れようと思ったのは何か縁があったのかもしれない。そこで飼い主に捨てられた犬たちを見るのは心が引き裂かれるような体験だった。とても不機嫌な顔つきの、しかしハンサムな姿をした犬が目に止まった。その瞬間、その犬を飼おうと決意したのはごく自然なことだった。

スタッフのひとりにその犬をもっと近くでみられるかと訊いた。檻から出されて連れてこられると、すぐに元気な様子になった。どうして彼女がここに連れられてきたのか理由を尋ねると、彼女は飼い主に捨てられていたのを保護され、この施設で3ヵ月を過ごしていたのだった。何人かが彼女を引き取ろうとしたが、誰にも懐こうとはしなかった。

そのとき、彼女がサセックス・スパニエルだと知った。その犬種のことを聞いたのはそれが初めてだったが、後でわかったのは、絶滅寸前の犬種だということだ。これまでの経緯を考えると、彼女を飼うことを決める前に少し熟考した方がよいように思われた。

次の日、施設に電話して、試しに彼女を連れていくことは可能か訊いた。彼らが許可をくれたので、彼女を迎えに行き、バドミントン・ホース・トライアルへ連れて行った。彼女は素晴らしかった。私は彼女を飼うことを決めたのだが、彼女の名、それはチャーリーだった。彼女はおよそ14年にわたり、私の相棒になった。

チャーリーはオフィスや店に私と共に出勤し、2匹目のサセックス・スパニエルのブラウニーと一緒に、私の書籍『ミスター・クラシック』と同

One afternoon about twenty years ago I was passing Battersea Dogs and Cats Home when on impulse I decided to drop in, never having visited before. It was a heart-rending experience to see all those unwanted dogs. I spotted one animal looking very glum but with handsome features, and at that moment I decided that was the dog for me. It was a spontaneous decision.

I asked one of the staff if I could look at her more closely. She was taken out of her quarters and immediately perked up. I enquired after the reason she had ended up in the home. It transpired that she had been abandoned and had been in the home for three months. Several people had taken her on trial but found her to be too difficult.

I then learned that she was a Sussex Spaniel – the first time I had heard of a breed that I later discovered was on the list of endangered breeds. I was a little reticent about owning her, given her chequered history, and so I thought I would mull it over before making such a commitment.

The next day I telephoned Battersea to see if they would allow me to take her on trial, which they agreed to do. I picked her up and took her to Badminton horse trials, and she was brilliant. I decided I would keep her, and her name, which

様に、〝ハケット〟の広告キャンペーンにも登場した。サセックス・スパニエルはもともと狩猟用の犬として改良された品種だったので、彼らはシューティングには馴染みがあったが、私の方で参加させるシューティングといえば、もっぱらフォト・シューティング（写真撮影）ばかりだった。

　ある日、サセックス・スパニエル協会から連絡が来て、パトロンになってはくれないだろうかという、喜ばしい依頼があった。チャーリーとブラウニーが亡くなってからしばらく犬を飼う気はしなかったが、相棒の犬たちや彼らとのエクササイズが恋しいと、内心では思っていた頃だった。今は２匹のサセックス・スパニエルを飼っている。マフィンとハリーだ。犬は飼い主に似るとよく言うが、私の２匹の犬たちは高貴でハンサムであるとだけは言っておこう。

（注１）バターシー・ドッグス＆キャッツ・ホーム／ロンドン南部バターシーにある1860年に創立された英国でも最古の犬と猫用の保護施設。
（注２）バドミントン・ホース・トライアル／創立1949年、ボーフォート公爵家の領地であるバドミントンで開催される世界最高峰の総合馬術競技大会。英国ではバドミントンというと、この馬術競技大会を指すことが多い。

was Charley. She became my constant companion for almost 14 years.

Charley regularly accompanied me to the office and the shops, and appeared in a number of Hackett advertising campaigns, as well as the Mr Classic book, along with my second Sussex Spaniel, Browney. They were originally bred as gun dogs for the shooting fraternity, but the only shoots mine have taken part in have been photo shoots.

One day I was contacted by the Sussex Spaniel Association, who wondered if I would consider becoming their Patron, something I was very happy to do. With the passing of both Charley and Browney I spent some time without dogs, but found that I missed the companionship and the exercise. Now I own two more Sussex Spaniels, Muffin and Harry. It is often said that owners take on the characteristics of their dogs. Well, my two are noble and handsome – need I say more?

92

Dog Day Afternoon

Partnerships
パートナーシップ

ある日、スローン・ストリート店にいたとき、〝アストン・マーティン〟のディレクターのひとりに出くわした。そのとき、彼は「何かぜひ、一緒にやろう」と言ったのだ。彼は私に二度訊ねる必要はなかった。世界で最も有名な英国ブランド（もちろん〝ハケット〟は別にして）と組みたがらない者などいるだろうか。これが現在まで続く、長く、実り多い信頼関係の始まりだった。〝アストン・マーティン〟のオフィシャル・メンバーとピットクルーに製品を作ることから始め、それが顧客への製品開発へと繋がった。私にとって正しいパートナーシップとは最後は顧客へつながることを指している。重要なのは英国と結ばれているパートナーシップだ。とどのつまり、私たちは英国ブランドなのだから。そういった理由でブリティッシュ・ポロ・デイとブリティッシュ・アーミー・ポロとのパートナーシップも継続している。これにより、ブランドに別の方向性が加わった。完全さと正統性を持つ正式なポロシャツを作ることができるようになったのだ。ロンドン・ローイング（ボート）・クラブはヘリテージとスポーツの価値を持つもうひとつの良い例で、この関係も大事にしている。ごく最近では、これにＦ１モーターレーシングチームの〝ウィリアムス〟のパートナーシップが加わった。Ｆ１グランプリで〝ハケット〟のロゴがスクリーンに閃くのを観ると、いつも気持ちが昂ぶる。そして私だけではなく、世界中の何百万という人もこれを観ているのだと実感する。

　私は顧客のひとりひとりとパートナーシップを結びたいと思っているので、店でイベントをよく開催している。最近では〝アストン・マーティンDB11〟の発表イベントをリージェント・ストリー

One day I was in our Sloane Street shop and I bumped into one of the directors of Aston Martin. He said to me, 'We should do something together'. I didn't need to be asked twice, because who wouldn't wish to be associated with the most famous British brand (apart from Hackett, clearly) in the world? It was the beginning of a long and fruitful relationship that endures to this day. We began by making kit for all the officials and pit crew of Aston Martin Racing, which developed into making products for our customers. For me the right partnerships are a way for us to engage with our customers. It is important for me that our partnerships are British, as we are after all a British brand. That is why we continue to partner with British Polo Day and British Army Polo. They add another dimension to the brand, allowing us to make proper polo shirts with integrity and authenticity. London Rowing Club is another example of a partner whose heritage and sporting values are to be cherished. More recently we have become partners with the F1 motor racing team Williams. It never ceases to give me a thrill when I watch a Grand Prix and the Hackett logo flashes across the screen, and I realise that not only have I seen it but so have millions of other people around the world.

I like to get our customers involved in

ト店で行った。私たちの顧客はいち早く最新の車を観ることができ、また〝アストン・マーティン〟社の社員とも話すことができた。類似のイベントを〝ウィリアムス〟とも開催し、ときにはロンドン・ローイング・クラブでのランチや〝ハケット〟ポロ・チームの試合観戦に招待している。これこそ楽しい顧客との繋がり方だ。アブ・ダビで開催されるF1グランプリを観戦するコンペティションも行っている。これはすべての経費を〝ハケット〟が負担し、ドライバーに会うことができ、ピットから観戦することもできるというものだ。参加する者にとって唯一の問題は、その週末を私と過ごさなくてはならないことだけだろう！私はこうしたパートナーシップをすべて心から楽しんでいるが、正直に告白すれば、そのどれにも物理的に関わっているわけではない。カーレースをすることはないし、〝アストン・マーティン〟を所有しているわけでもない（〝アストン〟がテストドライブを週末にさせてくれるにも関わらず）。ボートもやらないし、馬は大好きだが、ポロ競技をすることはない。思うに、私は大勢の顧客がその中にいて楽しんでいるのを見るのが好きな、貪欲な傍観者なのである。

our partnerships, so we often hold events in our shops. Recently we launched the new Aston Martin DB 11 at our Regent Street branch, so our customers were able to see at first hand their latest car, and talk with the people from the company. We have held similar evenings with Williams, and on occasion invited customers to have lunch at the London Rowing Club or spend a day watching the Hackett polo team in action. It is a fun way to connect with our customers. We have just run a competition for customers to attend the Grand Prix in Abu Dhabi – all expenses paid – meet the drivers and see the race from the pits. The only downside is that they will have to spend the weekend in my company! Much as I enjoy all our partnerships I have to confess that I do not physically take part in any of them. I don't race cars, I don't own an Aston Martin (although Aston let me test-drive a car for the weekend), I don't row, and – much as I love horses – I don't play polo. But I think I am probably much like a lot of our customers in that I am an avid spectator.

101
Partnerships

Goodwood Revival

グッドウッド・リヴァイバル

その時々の場面や状況に応じた装い、それは私たち英国人の得意とするところだ。アスコット競馬やヘンリー・ロイヤル・レガッタ、ポロ競技、いろいろある中で、イングランド南東部サセックスで行われるグッドウッド・リヴァイバルほど、それが明らかなイベントはないだろう。グッドウッドを先祖代々の領地として所有しているマーチ公爵は、良いショーのやりかたを心得ている。この1年に1回のイベントはソーシャル・カレンダーの中で最も人気のイベントとなり、今ではチケットを取るのも困難だ。このイベントでは参加する者全員が1940年代、50年代、60年代の精神に則って、ヴィンテージ・クローズに身を包むことが求められる。その時代に作られたクラシックカーとモーターバイクがイベントの主役で、週末を通してレースが行われる。

私は幸運にも〝アストン・マーティン〟に招待され、彼らのプライベートなパーティーに参加す

Any excuse to dress for an occasion and we Brits are up for it – whether it is Ascot, Henley Royal Regatta or a day at the polo we make every effort to look the part, and nowhere is it more apparent than at the Goodwood Revival in Sussex. Lord March, who owns Goodwood, knows how to put on a good show, and this annual event has become a hot ticket and one of the most popular dates in the social calendar. Everyone who attends is expected to enter into the spirit, and dress in vintage clothes from the Forties, Fifties and Sixties to complement the classic cars and motorbikes that are racing over the weekend.

I was very fortunate to be invited by Aston Martin to join them in their

ることになった。ただし条件つきだ。

「〝ハケット〟とスタイルのある着こなしについてパーティーで、当社のVIPゲストに語っていただきたいのです」

これが私の興味を引いた。パーティーには参加したいと思ったので、私のほうもひとつの条件付きで快く承諾した。「グッドウッドまで〝アストン・マーティン〟を貸してくれるなら」。彼らはそれが新しいDB11ではないと言ったが、そんなことは構わない。どんな〝アストン〟でも私には充分だ。

次の週末、〝アストン〟は順当に私の元に到着した。それはラピードSで、偶然にも私のお気に入りだった。圧倒的にエレガントで優雅な4ドアで、一見2ドアに見えるように巧妙にデザインされている。感情が高ぶって、「ああ、ホワイトだ」と言葉にすると、運転手は冷ややかに私を見て、こう言った。

「実はこの色は〝アストン・マーティン〟ではモー

hospitality suite – with one proviso: 'please would you give a talk to our VIP guests about Hackett and dressing with style?' I knew there would be a catch. So keen was I to attend that I willingly agreed – with my own proviso: 'will you lend me an Aston to drive down to Goodwood?' They pointed out that it wouldn't be the new DB11. I didn't care – any Aston would be fine by me.

The following weekend an Aston duly arrived: a Rapide S, which happened to be my favourite model. This machine is extremely elegant and refined, with its four doors so artfully designed that at first glance it appears to be only a two-door. 'Oh, it's white', I exclaimed. The driver looked at me icily and replied,

ニング・フロストと呼ばれております」

馬鹿なことを言ってしまったものだ。もちろん、そうだとも。道中、警官に呼び止められたらいいのにとさえ思っていた。かれらが車のナンバー・プレートについて尋ねたら、私はすらすらとこう答える。ナンバーは1AML、つまりAston Martin Lagonda（アストン・マーティン・ラゴンダ）〝アストン・マーティン〟社の正式社名というわけだ。

こうして車の手配はすべて整った。さらに苦悩の選択をせねばならない。果たして何を着ていくべきか？ 天気予報によれば猛暑となるらしい。この日のために事前に用意しておいたアンサンブルは、1948年に作られたダブル・ブレステッドのビスポーク・スーツでかなり重く660gもある。つまり、当時の上流階級が作らせた22オンスのスーツはとても着ていけないということだ。

ワードローブを見渡し、数年前に作ったライトウェイトのタン、60年代前半のスタイルのスーツを見つけた。こうなると、アイデアが頭の中で形になり始めた。

このスーツの持ち主は『タイムズ』誌の海外特派員記者であり、数々の不品行がたたってジェントルメンズクラブから追い出されている。編集長によって現地から報告をするよう、北アフリカへ送られた。それ以来、彼からの音信はなかったが、噂によれば、モロッコのタンジェの怪しいバーに潜伏しているとのことだ。

白のダブルカフスシャツを加え、カラー（襟）からキーパーを抜いて柔らかく見えるようにした。ストライプタイを選んだのは、彼があまり知られていないパブリック・スクールの出で、もっと有名なパブリック・スクールへの上昇志向を持っていて、彼のキャラクターを強調していると

'Actually it's called Morning Frost'. Silly me – of course it is. I was hoping that I might be stopped by the police on the way down, so that if they asked me what my registration number was I could remember with ease: 1AML.

Now that the motor was all organised I had more agonising decisions to make – what on earth was I going to wear? I had planned in advance my ensemble for the day, but then I heard the weather forecast. It was going to be baking hot, and the 1948 double-breasted bespoke suit I had chosen was so heavy – the cloth was around 660 grams, in old money about 22 oz – that it would be unbearable. Looking through my wardrobe I found a lightweight tan suit that I had made several years ago and had an early-Sixties look about it. I began to form an idea about the character who would own such a suit. I decided that he was a Times foreign correspondent who – through various misdemeanours, and having been blackballed from a number of clubs – has been shipped by his editor to North Africa, to report on matters there. Nothing has been heard of him since, although rumours suggest that he spends his time in seedy bars in Tangiers. I added a white double-cuff shirt, and removed the bones from the collar for a softer appearance. I took a stripe tie that looked as though

思ったからだ。装いを完璧にするため、ヴィンテージのアクセサリーを選んだ。1950年代頃のゴールドの〝ウォルサム〟ウォッチ（演じているキャラクターが質屋から請け出したばかりのもの）、1930年頃のゴールドのカフリンクス、杖の形をしたゴールドのタイピン、これも1930年代のものだ。これ以上の組み合わせが他に見当たらないのが〝ジョージ・クレヴァリー〟のタン・オックスフォード・シューズだろう。200年以上前のロシアン・カーフで作られたものだ。これ以上古いヴィンテージは手に入らない。最後の仕上げとして、シルクのポケットスクエア、1937年のジョージ6世の戴冠を記念し、ユニオン・ジャックで飾られたものを加えた。

　こうしてすべての準備を終え、私のキャラクターも決まったところで、ようやく就寝となった。人が私をなんと考えているか、わかっている。違う惑星に住む異星人だと思っていることだろう。

　リヴァイバル当日、イベントの記録を助けてくれるジャーナリストとフォトグラファーと共にグッドウッドに向かった。〝アストン〟でのドライブは夢そのもので、サリーヒルズを抜けて、眠っているような村々や、サセックスへ向かう道中のアーツ＆クラフツ・スタイルの家々を通って行った。とうもろこし色の大地は早朝の霧で覆われていた。それはその日の天気が極上のものになるサインだった。

　グッドウッド・エステートの中央にあるパークランドのケンネルクラブに〝アストン・マーティン〟で到着したのは朝食にちょうど良い時間だった。ホワイトの〝アストン・マーティン〟、実際はモーニング・フロストだが、そこではその車を実際に運転したかと訊ねられた。全員でレース

it could have come from a minor public school, which this character insisted on wearing while elevating himself to a more esteemed school. To complete the outfit I added vintage accessories: a gold Waltham watch from the Fifties (which he had just recovered from the pawnbroker); gold cufflinks circa 1930; and a gold tie pin in the shape of a walking cane, again from the Thirties. And what could be more fitting than my George Cleverley tan Oxfords, made from Russia calf that was more than two hundred years old? You can't get more vintage than that. For a final flourish I chose a silk pocket square adorned with Union Jacks that had been made to celebrate the coronation of George V in 1911. My kit prepared and my character in place, I retired to bed. I know what you are thinking: this guy lives on another planet.

On the morning of the Revival I drove down to Goodwood, accompanied by a journalist and a photographer to help record the events of the day. The Aston was a dream as we cruised through Surrey Hills, past sleepy villages and Arts & Crafts houses into Sussex, passing cornfields shrouded in early morning mist, a sign that the weather would be glorious.

We arrived at the Kennel Club, set in parkland in the middle of the Goodwood

Goodwood Revival

を観戦したり、驚嘆に値するクラシックカーを眺めたりする前に、友人のジャーナリストの助けを借りて、VIPゲストとの質疑応答を無事に終えた。その間にフォトグラファーがスナップ撮影を行った。人々は全員、その時代背景に合わせたコスチュームを身にまとい、その雰囲気は途方もなく素晴らしいものだった。兵隊からモッズ、ロッカー、さらに映画スター、ヴェロニカ・レイク(注1)のようなヘアスタイルにペンシル・スカート、シームの入ったストッキングをはいた映画スター（実際は男だったが）もいた。すべての場面が素晴らしく、楽しい雰囲気に満ちていて、オールドファッション・スタイルの本物の英国イベントだった。駐車場を離れようとしたとき、ヴィンテージ・ソフト・トップの〝アストン〟に乗ったグラマラスなご婦人がサングラス越しにじっと見て、物憂げにこう言った。「あなたのホワイトの〝アストン〟好きだわ、素敵ね！」。実際、その色は……まあ、ともかくとして、そういうことだ。

estate, in good time for breakfast with Aston Martin. I was asked if I was driving the white Aston. Actually it's Morning Frost, I replied. With the help of my journalist friend we would conduct a question-and-answer session with the VIP guests while the photographer snapped away, before we all left to watch the motor racing and gawp at the most amazing classic cars. The atmosphere was tremendous, with people dressed in all manner of period costumes, from soldiers to mods and rockers. There were movie star lookalikes with Veronica Lake hair, wearing pencil skirts and seamed stockings – and that was just the guys. The whole occasion was enormous fun, and a real British day out, in the old fashioned way. As I was leaving the carpark a glamorous lady in a vintage soft top Aston peered over her sunglasses and drawled, 'I love your White Aston – it's divine'. Actually it's… Whatever.

(注1) ヴェロニカ・レイクはアメリカ出身の女優。カールしたロングヘア、主に1940年代にフィルム・ノワールのファム・ファタール（運命の女）役で人気を博した。

Family Holidays
家族の休日

私の家族のお気に入りの休日はいつもデヴォンかコーンウォールで過ごしていたのを覚えている。私自身はコーンウォール半島の沖合にあるシリー諸島で過ごすのを気に入っている。今も英国での休日と言えば、こうしたイングランド最南端に位置する地域に心魅かれる。

数年前、セントアイヴスに近い、ヘイルと呼ばれる海辺のリゾート地を再訪し、砂丘に建てられた羽目板式（クラップボード）のビーチハウスに滞在した。1960年代以来、ビーチハウスはほとんど変わることなく、アイスクリームのようなパステルカラーに塗られていた。

かつて『インディペンデント・レヴュー・マガジン』誌に旅行に関する記事を書いてくれと頼まれたことがある。世界中どこでも選べたが、結局シリー諸島を書くことにした。そこが果たして変わってしまったのかどうか、興味を惹かれたからだ。実際はほとんど変わっておらず、ほぼ私の記憶通りだった。穏やかで手つかずの状態でそこにあり、あたかも昔に返ったような気がした。

そのときはトレスコ島に泊まった。セントメリーズ島へ行く途中のヘリコプターは後ろに3人の乗客がいるだけだった。彼らに「どこに泊まってるんだい？」と訊かれたので「パブだよ」と私は答えた。「私たちがトレスコ島を持ってるんだ、修道院にディナーに来るといい」と彼らは言った。

実際、車もほとんどなく、その光景は1930年代のイングランドのようだった。それは素晴らしかった。

私が英国での休日を楽しめる理由のひとつは、マフィンとハリーを連れて行けるからだ。旅行先で、彼らは私よりもっと休日を楽しんでいるようなのだ。

I remember with fondness family holidays, which were always taken in Devon or Cornwall, or my favourite, the Isles of Scilly, a group of islands off the Cornish coast. Whenever I holiday in Britain today I am drawn to these most southern of English counties.

A couple of years ago I revisited a seaside resort near St Ives called Hayle, and stayed in a clapboard chalet nestled in the sand dunes. The chalets had barely changed since the Sixties and were still painted in the pastel colours of ice cream. I was once invited by The Independent Review magazine to write a travel piece. I could have chosen anywhere in the world, but I settled on the Isles of Scilly because I was intrigued to see if it had changed. It hadn't – it was just as I remembered, tranquil and unspoilt. I felt as though I had stepped back in time.

Because there are very few cars on the islands – on some there are none – it's like England in the Thirties. It's fabulous. I chose to stay in Tresco. I was on the helicopter going over to St Mary's and it was empty except for three guys at the back. They started chatting, and asked me where I was staying. I said, 'At the pub'. To which they replied, 'We own Tresco – come up to the abbey for dinner'.

One of the reasons I so enjoy holidaying in Britain is because I can take my dogs,

かなり広範囲に旅しているが、通常はビジネスであり、観光する時間はほとんどない。私はビジネスと休暇を一緒にすることが得意ではないし、むしろ、別々のほうがいい。オーストラリアに住んでいる家族がいるので、できることなら毎年訪れたい。メルボルンに近いモーニントン半島にある可愛らしいビーチハウスに泊まったり、そうでなければ、アメリカのサヴァンナ（ジョージア州）にいる家族を訪ねるのもいい。そこは最も美しく景観が保たれた都市のひとつだ。

Muffin and Harry, who seem to enjoy the holidays even more than I do.

While I travel fairly extensively, it is usually on business, so I am in and out of a country in a matter of days, with little time to take in the sights. I am not very good at mixing business with holidays; I prefer to keep them as separate entities. Because I have family in Australia I try to visit every year, and I tend to stay at a lovely beach house on the Mornington peninsular, near Melbourne. Or I sometimes visit family in Savannah, Georgia, one of the most beautifully preserved and historic cities in the USA.

India: *A Country That has Inspired Me*
インド：私を魅了する国

118

私は初めて滞在したときからずっとインドに魅了されている。それはムンバイのザ・タージ・マハール（ホテル）で、クリスマスのことだった。ガラガラのホテルのプールサイドに座り、カレーのクリスマスランチを楽しんだ。

次の日はゴアへ飛行機で行き、タージ・マハールに泊まる予定だった。ホテルに着いたとき、私の予約は無く、ホテルは満室だった。私のドライバーは「心配するな、いとこが家に泊めてくれるから」と言う。彼は私を〝オースティン・アンバサダー〟に乗せ、埃っぽい道を一時間以上走った。辿り着いたのはシーサイド・コテージというサインのある、一晩2ポンドで泊まれる、ビーチにある小屋だった。漏電しているのか、シャワーを浴びるたびに電気ショックが走り、ベッドリネンは数週間も変えられていないようだった。

これまた別の彼のいとこから〝ロイヤル・エンフィールド〟のモーターバイクを借り、付近のエリアを探索した。うら寂しいヒッピーコミューンを訊ねたり、道の真ん中で休んでいたのを起こしてしまい、怒り狂った牛に突撃されたりした。地元のマーケットでマドラス・コットンを買ったことはよく覚えている。50ペンスのコットンからショーツを作った。

この旅は私の中で最高の休日のひとつとなった。あの時のショーツは今もどこかにとってある。

I have always been attracted to India, from the first time I visited and stayed at the Taj Mahal in Mumbai on Christmas Day, when the hotel was deserted and I sat by the pool enjoying a curry Christmas lunch.

The next day I took a flight to Goa, with plans to stay at the Taj Mahal there. When I arrived I was told there was no record of a booking and the hotel was full. My driver said not to worry, his cousin could put me up. He drove me in his Austin Ambassador for over an hour along dirt-track roads until we arrived at a sign that said Sea Side Cottages. For two pounds a night I had a shack on the beach. I was electrocuted every time I took a shower, and the bed linen looked as though it had not been changed in weeks.

I rented a Royal Enfield motorbike through another cousin and explored the area, visiting rather sad hippy communes and being charged by an irate cow that had been resting in the middle of the road. I remember buying Madras cotton fabric from the local market, which I had made into shorts for a cost of about fifty pence. It turned out to be one of my best holidays. I still have the shorts somewhere.

India : A Country That has Inspired Me

Souvenir from the trip
旅の土産

飛行機の座席に座り、離陸すると、そこから次の旅への興奮を感じ始める。前に訪れたことのない国ならなおさらだ。

アパレル業界にいることから、その国の原産品は何だろうと考える。皮革製品が有名だったり、靴作りやストリート・マーケットで知られているかもしれない。その国のよく知られたもの、言ってみればカウボーイハットやバンダナなどを家に持ち帰るのが好きなのだ。

バルセロナで、エスパドリーユだけを作っている店を訪れたことはよく覚えている。幾千というエスパドリーユをストックしていて、向かいの店では麦わら帽だけを作っていた。

もし日本にいたなら、日本で作られた製品、メイド・イン・ジャパンを買うだろう。私はいつもその国で作られた製品に触発されてきた（距離というレンズが魔法をかけてくれるのかもしれない）。私がインドにいるとしたら、ヨーロッパ製のラグをなぜ買う必要があるだろう？

It is not until I am in my seat and the plane has taken off that I begin to feel excited about the forthcoming trip, particularly if it is to a country that I have not visited before.

Because I am in the clothing business I start to wonder what products are indigenous to that country: maybe they are famous for their leather goods, or renowned for their shoemaking, or perhaps their street markets. I like to return home with something from a country that it is well known for – say its cowboy hats or its bandanas. I remember being in Barcelona and visiting a shop that only made espadrilles and they stocked them by the thousand; and a shop opposite that only made straw hats.

If I am in Japan I am interested in buying product that is made in Japan. I am always inspired by the goods of the country (it could be that distance lends enchantment). For instance, why, if I am in India, would I buy a rug that was made in Europe?

Packing
パッキング

パッキングは苦痛以外の何物でもない、特にビジネストリップが問題である。持っていくものが多過ぎるのが常だからだ。旅行中の気候がどうなるかわかりはしない。暑くなるならばライトウェイトのスーツとジャケットが必要だし、雨が降るならレインコートがいる。もしスーツケースにスペースがあれば、旅行用の傘も加える。

通常は〝グローブトロッター〟のスーツケースで旅行しているが、それが一杯になればパッキングはそこまでだ。常に幾つかの雑誌のインタビューを受けなければならないので、ブランドを代表する身としては、端正な服装は彼らに対する礼儀でもある。彼らに「かわいそうに、ハケットさん、一着しかスーツがないんだな」と思われないよう、全体のコーディネートにも気を配る。

パッキングはベッドの上に数着のスーツとジャケットを並べることから始める。パンツ（トラウザーズ）、シャツ、タイ、数枚のポケットチーフを加える。カフリンクスや時計も忘れてはならない。私にここで靴の話はさせないでほしい（話し始めたら止まらなくなる）。最後に、靴下と下着を投げ入れて終了だ。ここで何か忘れていたら、旅先で買い物に行く絶好の言い訳ができたというものだ。

フライトの日はネイビーのライトウェイトのブレイザーにジーンズ、最も快適なシューズ、〝LLビーン〟のモカシンか、よく履き慣れたコードヴァン・ローファーを履くことにしている。気が進まないが、長距離のフライトには私の医者が強要する特別な靴下、彼が言うところでは血栓のリスクを減らす効果のある靴下を履く。

機内には小さめのホールドオールバッグ（ボストンバッグ）にカメラ、ノートブック、iPad、

I absolutely hate packing, especially for business trips. I generally take far too much, because I am not sure whether it will be hot – in which case I had better take a couple of lightweight suits and jackets – or raining, in which case I better take a raincoat, and if there is room I might add my travelling umbrella.

I usually travel with my Globetrotter suitcases, and once they are full that's it. Invariably I have to give interviews with various magazines, so it is polite to dress well, as I am representing the brand. I try to vary my ensemble so that people don't think, 'Poor chap – he's only got one suit'. I generally start my packing by laying out on my bed some suits and jackets, to which I add trousers, shirts and ties, plus a couple of pocket squares. Mustn't forget cufflinks, watches, and don't get me started on shoes. Finally I throw in socks and underwear, and if I have forgotten anything I have the perfect excuse to go shopping when I arrive at my destination.

On the day of my flight I usually wear a navy lightweight blazer with a pair of denims and my most comfortable shoes, which are either my LL Bean moccasins or a well-worn pair of cordovan loafers. Although I loathe them, for long flights my doctor insists that I wear special socks when in the air, which apparently reduce the risk of blood clots.

数冊の小説を入れて持って行く。ここで最も重要なもの、パスポートも忘れてはならない。

　幸運にもビジネスクラスで飛ぶことができるのだが、機内では最も醜悪なトップスとボトムスに着替えることを勧められる。申し訳ないが私にはどうしようもない。これは私に幼稚園にいた子供の頃を思い出させるのだ。

I take a small holdall onto the plane to carry my camera, notebook, iPad and a couple of novels – oh, and most importantly my passport. Fortunate as I am to be able to fly business, once I am on board I am offered the most hideous top and bottoms to change into. I'm sorry, I just can't do it – it would make me feel like a child in kindergarten.

Japan: *Kyoto, Fukuoka, Kobe and Tokyo*
日本：京都、福岡、神戸、東京

何十年にもわたって、日本には何度も訪れている。最初の旅行は1989年だが、実際にはこの国を探求する時間はいつも十分にないように感じる。そのときは日本人の同僚が親切にも京都、神戸、広島、福岡への旅をアレンジしてくれた。私たちは東京から新幹線に乗り、まず京都へ行った。駅であらかじめ準備されたおいしくて新鮮なサンドウィッチをピックアップした。富士山を通り過ぎたとき、頂上は霧で覆われ、神秘的でオリエンタルな存在感が漂っていた。

京都は仏教の寺と庭園で有名であり、鮮明に覚えているのは完璧に敷き詰められた白い砂利の石庭だ。すべてがシンプルだった。シンプリシティというのは到達するのが難しいが、それは日本人が何かと優れている点だろう。平面からの光と相まって、全体の雰囲気に静寂が加わり、平和と心の平静を保つ感覚は魔法のようだった。非常に精神を高揚させる体験だ。

それから伝統的な木造家屋で昼食をとった。そこは美しい障子で仕切られ、木の床には畳が敷かれていた。全員そこで靴を脱がなくてはならなかったが、なぜ日本人が靴に気を使うのか、ここで不意に思い至った。彼らが靴を脱ぐとき、最も避けたい事態は安物の靴を人目に晒すことなのだ。私が自分のブローグの〝ジョージ・クレヴァリー〟の靴紐を緩めていると、彼らが脱いだ靴の行列が目に入った。〝J.M.ウェストン〟のローファーや〝エドワード・グリーン〟のドーヴァー、なかには艶やかに磨かれた〝ブルックス・ブラザーズ〟のコードヴァン・タッセル・ローファーもあったのだ。

日本人が靴にたいしてどれほど真剣か、これでわかるというものだ。

Over the years I have been to Japan many times, but not really had the time to explore the country, although on my very first trip in 1989, my Japanese colleagues had kindly arranged a tour taking in Kyoto, Kobe, Hiroshima and Fukuoka. We took the bullet train from Tokyo to Kyoto, picking up a lunchbox of delicious freshly prepared sandwiches at the station. We passed Mount Fuji, the top of which was shrouded in mist that only added to its air of mystery.

Kyoto is famous for its Buddhist temples and gardens, and I remember vividly a rock garden surrounded by perfectly raked white gravel – all so simple. Simplicity is hard to achieve but it is something the Japanese excel at. The sense of peace and serenity was magical, with the flat light and stillness adding to the atmosphere. It was a very uplifting experience.

We stopped for lunch at a traditional wooden house, where the rooms were divided by what appeared to be fine parchment, and the wooden floors were covered in rush matting. We all had to take our shoes off, and it struck me then why the Japanese are so particular about their footwear – because when they enter a house the last thing they want is to be seen with shoddy shoes. As I untied my George Cleverley brogues, I noticed among the array of discarded shoes a

床に座って食事するのは私にとって新しい経験だった。1時間以上、床の上に足を組んで座るのも辛かったが、そうしながら箸を使うのはなおさらである。

　福岡ではバーに連れて行かれ、そこでカラオケに参加するという重大な責務が問われた。おびただしい量の酒を飲んでから、突然理解したのは、大量の酒は精神を高揚させ、歌うためにあるということだ。そんな状況で歌うと言えば、むしろ怒鳴っているようなものと思うかもしれないが、私は「霧のサンフランシスコ」を低い声でくちずさみ、礼儀正しい拍手がそれに続いた。こうして無事に私の名誉は保たれたのだった。

　神戸では神戸牛を初めて口にしたが、それ以来、それを超えるものには出合っていない。

　2011年、東京を旅したときのことだ。〝ハケット〟の店舗で接客中だったことをはっきりと覚えている。急にめまいを覚えたが、最初、それは一日中何も食べていなかったからだと思った。しかし、スタッフのひとりが私を掴んで何か叫ぶと、テーブルの下に強引に押し込んだ。地震だった。地震が過ぎ去って、外に出てみると、空気は重く、雰囲気は不気味で湿っぽく、不吉な予感がした。日曜日、街はいつもと違って静まり返っていた。ニュースは東北の津波とその惨状を伝えていた。私はマーケットを散策して、古い仏像の石頭を見つけた。そのときは、それを買うのが正しいことのように思われた。

　次の日、帰りの飛行機の中で何か日本を援助する方法はないものだろうかと考えていた。そこで、この災害援助のために特別なポロシャツをデザインした。売り上げからすべての利益が復興支援機構へ寄付されるものだ。

couple of pairs of JM Weston loafers, a pair of Edward Green Dover shoes, and a highly polished pair of Brooks Bros cordovan tassel loafers. It was patently obvious that the Japanese take their shoes very seriously.

Eating on the floor was a new experience for me, and sitting cross-legged for more than an hour was pretty painful, especially while juggling with chopsticks at the same time. In Kobe, I sampled Kobe beef for the first time and I have never since had better.

When we were in Fukuoka I was taken to a bar where I was duty bound to take part in a karaoke session. Having been plied with copious amounts of liquor I suddenly found the spirit to get up and sing. I say sing, but it was probably more like bawling, as I crooned my way through 'I Left My Heart in San Francisco'. That was followed by polite clapping, but honour had been restored.

On a trip to Tokyo in 2011 I can remember clearly being in the Hackett shop looking after customers when I became faint. At first I thought it was because I hadn't eaten all day, but one of the staff grabbed me, exclaiming that it was an earthquake, and shoving me under a table. When it seemed to have passed I went outside, where the air was heavy and the atmosphere eerie, humid and foreboding.

私は日本の文化、そして人々に魅了されている。いつか、この素晴らしい国の魅力を、より多くみることができるよう望んでいる。

On the Sunday the city was unusually quiet because news had come through of the devastation and tsunami in Tohoku. I strolled around a market, picking up an old stone head of Buddha. It seemed the right thing to buy at the time.

On my flight home the next day I wondered whether we could help in some way. I designed a special polo shirt, and all the profit from its sales went to the earthquake relief fund.

I am enchanted by the culture and people of Japan, and I hope one day to be able to see more of this fascinating country.

Jeremy Hac
photographs
yesterday &

kett

tomorrow

Chapter

3

BEING A GENTLMAN

Being a Gentleman
紳士になる方法

「ジェントルマン」という言葉の概念

「ジェントルマン」という言葉に人々が遭遇するとき、彼らの思考がすぐにイギリスと結びつくのは実に興味深い。イングリッシュ・ジェントルマンという思想は、世界中の男たちの想像力をかきたてる。

イギリスが紳士の国であるというロマンティックな考え方がある。文学でいうならイヴリン・ウォーの小説、ノエル・カワードの戯曲、映画なら「炎のランナー」や「ザ・シューティング・パーティー」(注1)、最近ではTVシリーズの「ダウントン・アビー」(注2)と、これら多くの要素によってその考えは作られている。

エドワーディアン（エドワード7世時代）のイギリスは、他のどの時代よりもイングリッシュ・ジェントルマンに対する認知が向上し、その価値が確立された時代だった。それは服装のみならず、エチケットとマナー、騎士道的精神、彼らの勇敢なる立ち居振る舞いにまで及んでいた。

当時、ジェントルマンになることは厳しく限定されていて、家柄、出身校、そして「地主階級」という表現が示す通り、所有している土地によって判断された。ジェントルマンというからにはイギリスの2大パブリック・スクールのどちらか、イートン校かハーロウ校に通っているのが当然だった。

実務としての仕事はむしろ蔑視され、教会もしくは軍隊に、将校や司教としてつとめることはかろうじて許容されていたが、ほとんどの場合、ジェントルマンといえば「領主の土地」という遺産を相続し、そこでは狩猟、射撃、釣りを行って時を

Gentleman: the word and the concept

It is curious that when people encounter the word Gentleman their thoughts immediately turn to England. The idea of the English Gentleman is one that has captured the imagination of men the world over. There is a romantic notion that England is a nation of Gentlemen, one that is compounded by literature – the novels of Evelyn Waugh, the plays of Noel Coward – and by dramas such as Chariots of Fire, The Shooting Party and more recently the television series Downton Abbey, as well as many others.

Edwardian England more than any other period lay down the values that create our perception of the English Gentleman, and not only through dress but etiquette and manners, chivalry and gallantry.

At the time, being a Gentleman was very restricted, being judged by family background, schooling and the owning of land, hence the expression landed gentry. It was expected of a Gentleman to attend either Eton or Harrow public school. To actually work was frowned on, although entering the Church or the Army as a commissioned officer was acceptable. But in most cases Gentlemen inherited a country estate, where they would pass the time hunting, shooting and fishing, and entertaining guests of a similar stripe.

過ごし、ゲスト同様に自分たちも趣味を楽しむことに時間を費やしていた。

服装には厳密なルールがあり、「キツネ狩り」に行くと言えば、それにふさわしい服装でなければならなかった。もし相応の服装ができなかった場合、再び招待を受けることはないだろう。

もちろん、今日では領主の土地を所有し、狩猟、射撃、釣りに興じる人はかなりの少数派であり、現代に生きる我々は仕事もしなければならない。しかし、ジェントルマンのマナーにのっとって、テーラリングの美学に裏付けされた紳士的な装いを楽しむことは、現代の我々にも可能だ。

とどのつまり、ジェントルマンのように装うということはこの一点に尽きるからだ。良いマナー、他者への配慮、フェアプレーの精神無くしては、決してジェントルマンになることなどできない。

紳士的に装うとは

私が20代のとき、ジェントルマンのテーラリングの聖地、世界に名を馳せたサヴィル・ロウで働く幸運に恵まれた。そこで著名なクチュリエ、ハーディー・エイミス氏とも何度か会う機会があった。彼はかつて私にこう言った。

「ジェントルマンは大いなる配慮を持って装い、一度身に付けたら、それを忘れるべきだ」。以来、この言葉は幾度となく私の中で繰り返されている。実に賢明な言葉ではないか。装うということは、決して過剰にならないこと、どんな衣類を持っているかは重要だが、ただ着用することは余り重要ではない。

奇抜なファッションは無視すべきだし、自らのスタイルに自信を持つべきだ。エキセントリック

There were strict rules regarding dress. Being inappropriately attired to go fox hunting for example would be met with disapproval, and it would be unlikely that you would be invited back. Of course today few of us own country estates, hunt, shoot or fish – and most of us need to work – but we are still able to enjoy the sartorial elegance of dressing in the manner of a Gentleman. Dressing like a Gentleman is one thing, but without good manners, consideration for others and a sense of fair play one can never truly be a Gentleman.

How to dress like a gentlemen

When I was in my twenties I was fortunate to work in Savile Row – the bastion of Gentlemen's tailoring, famous the world over. I met on several occasions the famous couturier Hardy Amies, who once told me (and I have seen it quoted numerous times since) that 'A Gentleman should dress with great care, then forget about it'. Wise words indeed. It is about dressing, but not overdressing. It is more a case of owning your clothes, not merely putting them on.

You should ignore the vagaries of fashion and be confident in your own style. There is much talk of the eccentric Gentleman, but beware: forced

なジェントルマンに対しての言及は多いが、不自然な奇抜さは過剰な自意識を表出させ、やや滑稽でさえある。エキセントリックな装いは、自分のスタイルから自然に滲み出てくるものでない限り、避けた方が無難といえる。

　過去には、紳士のワードローブは日常の必要性に応じて明確に構成されていた。タウンウェアとしてのセットスーツ、カントリーウェアとしてのツイードスーツとジャケット、フォーマルな場面に対応するイヴニングクローズと、すべてに用途に適した機能性が重視されていたのである。同時に、身体にフィットする完璧な仕立てであることが求められ、何より、これらの洋服は長持ちすることが求められた。イギリスでは着古すという言葉を wear out と表現する。何年か前に、私はこんな言い回しを思いついた。「服というものは長持ち(wear in)させるべきで、着古す (wear out) べきではない」というものだ。

　ジェントルマンが断じて避けなくてはならないのは、新興の成金と誤解されることである。そのためには洋服が新しく見えないよう気を配るべきだ。ウィンザー公は自身がスーツを着用する前に、彼の従者に新しいスーツとジャケットを与え、着ならしをさせていたという逸話もあるほどなのだ。

　まだサヴィル・ロウで働いていた頃、私がよく覚えている事件がある。ある貴族がやってきて、非常に無礼な振る舞いをした。支払い前に完成したスーツの受け取りを要求したのだ。「閣下、最後の支払いをお済ませになるときに受け取りはお願い致します」とテーラーは説明した。この言葉を聞いて激昂した彼は、「どこか他の店へ変えるぞ」と捨て台詞を残して店を立ち去った。ちょう

eccentricity can appear to be self-conscious and faintly ridiculous – if it doesn't come naturally then it is best avoided.

In the past a Gentleman's wardrobe was very specific, consisting of clothes to suit his daily requirements. He would own a set of clothes to wear in Town, tweed suits and jackets for the Country, and evening clothes for formal occasions. It was all about function. At the same time he required that his clothes were perfectly made and well-fitting, and above all that they would last. Indeed some years ago I coined the expression that 'Your clothes should wear in, not out'.

A Gentleman was also conscious that his clothes should not look new. Heaven forbid that he should be mistaken for the newly rich. It has been rumoured that the Duke of Windsor would give his new suits and jackets to his valet to wear and break in before he deigned to wear them himself.

I remember while I was still working in Savile Row a particularly rude and opinionated Lord came in, demanding when his suits would be ready. The tailor replied, 'When you have paid for your last ones, your Lordship'. With that he stormed out, saying he would take his custom elsewhere. And yet I also looked after the sartorial needs of a taxi driver

どその頃、私の顧客にはタクシー・ドライバーもいた。彼はいつも直ちに支払いをしてくれた。どちらがより紳士であるかは言うまでもない。

最初の一着

　ジェントルマンを志す者のワードローブにスーツは不可欠だと、私はいつも考えている。そして1着の良いスーツは、3着の良くも悪くもないスーツを持つことよりいいことだと信じている。

　まず最初の一着としては、クラシックなカットのネイビーブルーのスーツに勝るものはない。生地はネイビーブルーのホップサックが最上だろう。控え目な光沢があり、ミディアムでもライトウェイトでもつくることができる素材だ。

　どんなスタイルを選ぶかは、完全に個人的な事柄だが、よいテーラーなら顧客を正しい方向へと導いてくれる。最も伝統的なスタイルは3ボタンのシングルブレステッド、センターベントにスラントポケット、4つボタンのワーキングカフ（本切羽）といったものだ。これはジェントルマンが狐狩りの際に着用した乗馬用ジャケットから派生したスタイルだ。トラウザーズ（パンツ）は騎兵隊が着用した細身のスタイルであり、ベルトループ付きのものよりはサイドアジャスター付きで着用されていた。そもそもパンツは本来ブレイシズ（サスペンダー）と共に着用するために作られている。オスカー・ワイルドがいみじくも語ったように、「パンツは肩から吊られるべきでウエストからではない」。

　初期の頃のハケットでは、これはシングルブレステッドのみの仕様だった。しかし、時代は変わった。この仕様は依然として好まれているが、若い

who never failed to pay his bills on time. I know which one was more of a Gentleman.

The first suit

I have always considered the suit to be an essential item for any aspiring Gentleman's wardrobe, and I believe it is better to own one good suit than three mediocre ones. As a starting point there is nothing better than a classically cut navy blue suit. Navy blue hop sack cloth is the best – it is less shiny and can be made in a medium or lightweight material.

How you choose the style of your suit is entirely personal, though a good tailor will point you in the right direction. The most traditional style would be a three-button single-breasted suit with a centre vent, slant pockets and a four-button working cuff. It is a style that has evolved from the riding jacket that Gentlemen wore out in fox hunting.

The trousers would be cut in narrow cavalry style, and worn with side adjusters rather than belt loops. The trousers would be made to wear with braces – as Oscar Wilde famously said, "trousers should hang from the shoulders not the waist".

At Hackett in the early days this was the only single-breasted style we sold, but times change and while some Gentlemen

163

Being a Gentleman

To Jeremy – a man of style
from the daughter of another
man of style
 Love,
 Ava

顧客の多くは2ボタンのシングルスーツにサイドベンツ、1ボタンスーツにピークラペルといったものを選んでいるようだ。スタイルは長い年月をかけて進化していくものかもしれないが、可能な限り最上のものを買うこと、カットとクオリティは重要という原則は、依然として生き続けている。

今日ではテーラリングが復権し、ライニング（裏地）を選んだり、遊び心のある違うカラーのボタンホールや、反対色の糸をボタンに使用したりといった、スーツをパーソナライズすることが好まれている。しかし、秘訣はやり過ぎないこと。スーツのどこかに自分好みのタッチがあれば、それで充分だ。

ここに1930年代のテーラリングに関する本から見つけた引用がある。「ジェントルマンはそれと気づかれないような装いをすべきである」。全面的にこの意見には賛成だ。賛成しているにも関わらず、つい私は期待してしまうのだ。私の装いと、そのために行った全ての努力、このことに周囲の人々が気が付いてくれることを。恐らく、この意味においては、私は紳士的ではないのだろう。

シャツとシューズ

若いジェントルマン諸君が高価なスーツに投資をしたにもかかわらず、仕立ての良くないシャツや、さらに残念なことには安物の靴で、全体を台無しにしてしまっているのを、私はしばしば目にしている。

ダブルカフのカットアウェイカラーのシャツは常にスマートなスーツとよく合う。シャツの襟は取り外しのできるカラーボーン（襟芯）で形作られるべきで、そうすることで然るべきネクタイ用

still prefer this cut, many of our younger customers are opting for two-button suits with side vents or one-button suits with peak lapels. Although styles may evolve over time, the principle still remains, in that you buy the best you can afford, and that cut and quality still matter.

There has been a revival in tailoring and today Gentlemen like to personalise their suits, either with the choice of lining or by sporting different colour button-holes or contrasting the thread on the buttons. But the trick is not to overdo it – a touch here and there is enough. Here is another quote I found in a Thirties book on tailoring: 'A gentleman should dress so as not to be noticed'. While I agree on the whole with the sentiment I rather like the thought that people notice my clothes, considering all the effort I have gone to. Perhaps that means I am ungentlemanly.

Shirts and shoes

I have often noticed how young Gentlemen are prepared to pay good money for an expensive suit, and then ruin the effect by wearing a badly made shirt or – worse still – cheap shoes.

A cut-away collar shirt with a double cuff always works well with a smart suit. The shirt collar should be made with removable collar bones, there should be a

のスペースが生まれる。さらにカラーは相応の高さにあるべきだ。

　袖はカフが1インチ（2.5cm）以上見えることがない、適正な長さであることも重要だ。

　タブカラーが最初に見られたのは前世紀の始めであり、1960年代にモッズや当時の映画俳優が着用したことから復活した。興味深いのは、ひとつの世代を代表する服装が次の世代には無視され、それからその次の世代によってまた取り上げられることである。ウィンザー公が着用したスタイルさえ、現在の流行に取り入れようとし、よりファッショナブルな視点で物事を捉えようとする若きジェントルマンの間で、タブカラーは今また人気を取り戻している。

　ジェントルマンは流行のファッションに飛びつく前に慎重になるべきだ。自分が持っているワードローブの服装と本当に合うものだけを流行から取り入れるようにし、ファッションの犠牲者にならないように注意するべきなのだ。特に気をつけたいのは、自らをクールに見せるという思い込みのもと、若者風に装うことだ。これほど男を老けて見せるものはない。

　そしてジェントルマンの装いを際立たせるのは靴をおいて他にはない。なぜかは分からないが、このことはしばしば忘れられがちだ。イギリスのグッドイヤーウェルト製法のベンチメイドシューズは、世界中から高い評価を得ており、長持ちする上に、ほとんどの場合、ときを経るごとに味わいを増し、そのスタイルは不変だ。黒か茶のブローグシューズにスーツは完璧な組み合わせだし、スエードもいいだろう。〝ジョージ・クレヴァリー〟、〝エドワード・グリーン〟、〝クロケット＆ジョーンズ〟といったメーカーは最高の靴を作っている。

decent tie space and the collar should sit reasonably high.

It is important that the sleeve length is correct, with no more than an inch of cuff showing. First seen at the beginning of the last century, and resurrected in the Sixties by mods and films stars alike, the tab collar is making a comeback. It is interesting to see how clothes of one generation are ignored by the next and then taken up by a following generation. So it is with the tab collar, which is now becoming popular for young Gentlemen who are pursuing a more fashionable vision, while at the same time picking up on a style that even the Duke of Windsor wore.

A Gentleman should be wary of jumping on the fashion bandwagon, and should look to take from fashion only what truly works within his wardrobe of clothes. He should be careful not to be the victim of a fashion whim. This is particularly the case for older Gentlemen, because nothing makes a man look older than dressing in adolescent styles under the misapprehension that it is making him appear cool.

Nothing marks a Gentleman out more than his shoes and for some unknown reason they are often the least thought about. English Goodyear welted bench-made shoes enjoy a worldwide reputation,

誰かがいみじくも言ったように、それが最上のものであれば、それで何も言うことはない。

アクセサリー

　抑制を持ってジェントルマンがアクセサリーをつけるにはどうするべきか。ジェントルマンが身につけられるアクセサリーは、実はほとんど存在しない。結婚指輪は例外として、イヤリングやメダリオン（メダル）、指輪をすることも認められない。一時的な流行に踊らされて入れ墨を入れるといった行為は、断固として避けなければならない。私にとってアクセサリーというのは、ヴィンテージ、または何か恐らく個人的なもの、たとえば家族代々受け継がれているカフリンクスなどを身につける良い機会だ。いずれの場合も、時計がスチールであればシルバーのカフリンクスの方がより調和することだろう。

　ポケットチーフはスーツのスタイルに個人的な味わいを加え、節度のあるスーツの着こなしの彩りとなる。一般的にポケットチーフとネクタイは合わせる必要はないが、合わせたとすれば、それはそれで効果のあるものだ。例えば、ポルカドット（水玉）のネクタイとハンカチーフは、私の考えでは、クラシックでありながら着こなしを生き生きとしたものにし、最新のものに変えてくれる。一時期は紳士的でないと思われていたタイピンも、最近では復活してきた感がある。私自身はシルバーのタイピン、それも愛犬であるサセックス・スパニエルのブラウニーからモチーフを得たタイピンを身につけることもある。タイピンには、ただのプレーンなネクタイが陥りがちな凡庸な着こなしを、文字通り持ち上げる効果があるのだ。

are made to last, and in most cases improve with age. The styles are timeless. Black or brown brogues are perfect with a suit, as are suede brogues – George Cleverley, Edward Green and Crockett and Jones make the best. And as someone said to me once, the best is good enough.

Accessories

How should a Gentleman accessorise? With restraint. There are few accessories a Gentleman can wear: certainly not ear rings, medallions or rings on his fingers, notwithstanding a wedding band, and the fad for tattoos is to be avoided at all costs. I think accessories are a chance to wear something vintage or personal, perhaps something that has been passed down through the family, such as cuff links. These in all cases should match your watch, ie if your watch is steel then silver links are more harmonious.

Pocket squares can add a touch of personality and colour to a sober suit. It is generally accepted that your pocket square should not match your tie. But sometimes it can work – for instance a polka-dot tie and hankie I think looks updated and graphic while still classical. The tie pin has been revived though at one time it was not considered Gentlemanly. I think today it seems right and I have

ブラウンのトリルビー帽に〝フォックス・ブラザーズ〟社のグレーのフランネルスーツを組み合わせるにせよ、リネンジャケットにパナマハットを組み合わせるにせよ、帽子は装いの完璧な仕上げとなる。ここで忘れてならないのは、建物に入るとき、または誰かに挨拶をするときは、ジェントルマンであれば必ず帽子は脱ぐものだ。

　カラフルな靴下は、全体の着こなしに、あか抜けたスマートな感じを与えるもうひとつの方法だ。明るい色のソックスはイギリスのジェントリー（紳士階級）には常に人気がある。これは彼らの学生時代、所属していたチームやハウスを示すために、異なる色やストライプのカラーのソックスの着用を求められた、その名残りなのではないかと思う。ピンストライプのスーツを着こなした落ち着いた身なりの紳士が、目を引くような明るいレッドやイエローの靴下を履いているのを、読者の方もよく見かけることだろう。画家のデヴィッド・ホックニーはミスマッチのカラフルな靴下で有名だが、彼こそ、スタイルから自然に滲み出るエキセントリックな着こなしの体現者だ。

ネイビーブレザー

　疑うことなく、ジェントルマンにとって最も重要な服をひとつ選べといわれたら、それはネイビーブレザーとなる。ドレスアップもダウンもできる、非常に便利なアイテムだ。クラシックなバラシア生地からリネン、キャンバスまでと作られる素材もさまざまだ。ネイビーブレザーはダブルブレステッドの真鍮ボタンを用いた、かっちりとした海軍風のミリタリーファッションにもなり得るし、夏向けのマザーオブパール（白蝶貝）のボ

taken to wearing one myself in silver that features my Sussex Spaniel, Browney. It helps lift an otherwise plain tie.

A hat can really complete an outfit, whether it is a brown trilby with a Fox grey flannel suit, or a Panama hat with a linen jacket. But remember a Gentleman always takes his hat off when entering a building or when greeting someone.

Colourful socks are another way to add flair to your ensemble. Brightly coloured socks have always been popular with the English gentry. I think it goes back to school days, when they were required to wear socks of different colours or stripes to denote which team or house they were playing for. You will often see a soberly dressed Gent in a pinstripe suit flashing a pair of bright red or yellow socks. The painter David Hockney, a man who wears eccentricity with natural ease, is famous for his mismatched colourful socks.

Navy blazer

Without doubt the single most important piece of kit a Gentleman should own is a navy blazer. It is incredibly useful and can be dressed up or down. It can be made in a variety of materials, from the classic barathea to linen or canvas. It can be structured in military fashion, like the double-breasted brass button

タンを用いたり、カーキのパンツに合わせてボーンボタンを用いたりすれば、もっとリラックスしたシングルブレステッドのスタイルにもなり得る。

　私が旅行するときはいつでも何かしらネイビーブレザーを持参するようにしている。ポロシャツとストライプのシアサッカーのパンツでカジュアルに着こなすこともできるし、淡いブルーのエンド・オン・エンド（刷毛目）生地のシャツに、テーラーで仕立てたグレーのウールのウーステッド（梳毛）のパンツならばフォーマルにもなる。

　休暇に持っていけば、ショートパンツの上に羽織って、エレガントにビーチからレストランまで行くことができる。格式のあるジェントルメンズクラブと同様に、ゴルフクラブでも着用可能だ。こうした理由から、旅に出るときに、ブレザーなしで家を出ることなどあり得ないのだ。

ブラックタイ

　これを書き終えたら、すぐにブラックタイのパーティーの準備にとりかかるつもりだ。私の招待状にはドレスコードが明確に示され、それを厳守しないのはホストに対して失礼というものだ。クリーニング店からは私のダブルブレステッドのディナージャケットが既に届いているし、マーセラ生地のドレスシャツはピシッとアイロンがかけられている。〝ジョージ・クレヴァリー〟の黒のオックスフォードシューズも入念に磨かれている。ここに黒のシルクのボウタイ（当然ながら手結びのもの）を結ぶことにしよう。

　仕上げとして、家族から受け継いだ〝ローレックス〟のスチールのエクスプローラーと、シルバー

Navy model, or can be more relaxed, in a single-breasted style, with mother-of-pearl buttons for summer, or bone buttons to wear with a pair of khakis.

　Whenever I travel I always take a navy blazer of some sort. I can wear it casually with a polo and striped seersucker trousers, or more formally with a pale blue end-on-end shirt and a pair of grey worsted tailored trousers.

　On holiday I can throw it over a pair of shorts to take me elegantly from the beach to the restaurant. It can be worn to the golf club as easily as to a Gentlemen's club. I wouldn't leave home without one.

Black tie

　As soon as I finish this book I shall be getting ready to go to a black tie party. My invitation has clearly stated the dress code and it would be rude to the host not to abide by it. So I have already picked up my double-breasted dinner jacket from the cleaners, my Marcella dress shirt is nicely laundered and my black Oxford shoes from George Cleverley have been spit-and-polished. I shall wear a black silk bow tie (self-tie, naturally).

　I shall accessorise the outfit with a steel Rolex Explorer that I inherited, and will wear silver monogrammed cuff links with silver dress studs. I shall add a black and

のモノグラムが入ったカフリンクスにシルバースタッズを身につける。ブラック＆ホワイトのシルクのポルカドットのポケットチーフをし、パンツのポケットには白のリネンのハンカチーフを入れた。最後にシルクの黒のロングソックスを履く。ジェントルマンなら正装に短いソックスなど夢にも考えないものだ。さて、大いなる配慮をもって行った今夜の装いだが、今度はそれを全て忘れ、パーティーを楽しむこととしよう。

では、タクシーを呼んでくれたまえ。

white silk polka-dot pocket square and a white linen hankie in my trouser pocket, and finally long silk black socks, as no Gentleman would contemplate short socks with formal attire.

So, having taken great care with dressing, I shall now forget all about it and enjoy the party.

Taxi!

(注1) 1985年製作、アラン・ブリッジズ監督、ジェイムス・メイソン主演の映画。1913年のイギリスを舞台に、第一次世界大戦前夜の貴族社会での狩猟パーティーを通して、当時の貴族社会の一面と凋落を描いた。
(注2) 1912年、ジョージ5世時代のイギリス、ヨークシャーを舞台に、大貴族の邸宅「ダウントン・アビー」で繰り広げられる人間ドラマを描いたイギリスの人気ＴＶシリーズ。

おわりに

本をつくるという作業は、人生における人の縁と同じだと思う。
つながる人とは、どんなに遠くに離れていても、つながるようになっている。
出版できる本はどんな紆余曲折があっても出版できるものだ。
この本は、美しき英国のメンズスタイル、
その唯一無二の体現者であるジェレミー・ハケット氏によるテキストと、
インスタグラムのためにジェレミー本人が撮影した写真をもとに作られている。
英国の文化は時に一筋縄では理解できない独特の魅力を持っているが、
ジェレミーが構築したエッセンシャル・ブリティッシュ・キットの世界観を、
少しでも多くの読者に理解していただけるよう、翻訳に傾注し、本を構成した。
この本の写真はテキスト同様に、彼がどう世界を捉えているのか、その視点を実に端的に表現している。
インスタグラムから作られた本という点でも非常に画期的な一冊だろう。
ジェレミーは忙しいスケジュールの中、テキストを送ってきてくれた。
それは誰もが感じたことがあるに違いない、親しい友人からの温かい手紙のような魅力に溢れていた。
一日の終わりに読むと幸福になれる、そんな魅力だ。本が無事に出版されて、
それは非常に喜ばしいが、もうあのギフトを受け取ることがないと思うと、少し寂しい。

この本の製作には実に多くの方々から協力を頂いた。
有能でエネルギーに溢れたハケット・リミテッドのジョージア・ファレイ氏、シャーロッテ・グレイス氏、
惜しみないサポートを頂いた（株）ハケット・ジャパンの大西慎哉氏、BLBG（株）の生駒貴子氏、
素晴らしいアートワークを発揮してくださったグラフィックデザイナー、H.D.O.の引田大氏、
今回も私の無謀な挑戦を引き受けてくださった（有）万来舎の藤本敏雄氏、大石直孝氏、
何より私を信頼し、共に本を作る貴重な機会を与えてくださったジェレミー・ハケット氏、
そしてこの本を手にとってくださった読者に心よりの感謝を贈ります。

長谷川喜美

Afterword

To me, the process of creating a book is just like making connections with people.
No matter how far away people might be, you can still find a way to get in touch. No matter how many twists and turns the draft of a book might take, you can still find a way to get it published.
This book is the work of Jeremy Hackett, the inimitable embodiment of the classic British men's style, who both wrote the text and took all the pictures—which originally appeared on his Instagram account. While British culture has its share of quirks and idiosyncrasies that make it a challenging context to navigate, I had do my best and tackle the clear task in front of me: capture the essence of Jeremy's "Essential British Kit" philosophy,
translate his ideas into Japanese, and bring his concepts to a wider audience.
The pictures in the book, like the text, are a revelatory window on how he sees the world.
That visual insight takes on an even more fascinating dimension when you
consider that all the photographs came from Instagram, a unique approach that only
adds to the book's absorbing, creative appeal.
When I got the text from Jeremy, who had taken time out of his busy schedule to pen the work,
I felt a distinct warmth in what he'd written—that kind of tenderness you sense in letters from
your closest friends, a calming contentment that certain words can bring you at the end of a long day.
Seeing the book through all the way to publication was a thrill like no other, to be sure,
but I still feel a tinge of sadness when I realize that I'll probably never receive a gift from him again.

So many people played enormous roles in making this book a reality. My gratitude goes out
to everyone, especially Ms. Georgia Farey and Ms. Charlotte Grace at Hackett Ltd.,
who always brought her immense talents and incomparable energy; Mr. Shinya Onishi at
HACKETT JAPAN Ltd. and Ms. Takako Ikoma at BLBG Co., Ltd., with their unending support;
Mr. Dai Hikita at H.D.O., the graphic designer behind the brilliant artwork; Mr. Toshio Fujimoto
and Mr. Naotaka Oishi at Banraisha Ltd., who was gracious (and open-minded) enough to
let me take up another wild project, and, most of all, Mr. Jeremy Hackett—the one
who gave me this absolutely fantastic opportunity to make this book together.
My last thanks go to all you readers who agreed to explore Jeremy's world with me.

Warmest regards,

Yoshimi Hasegawa

〈著者紹介〉

本文・撮影：Jeremy Hackett　ジェレミー・ハケット

ハケットロンドンの創設者で、現会長のジェレミー・ハケットは、英国ウィルトシャー州ディバイゼスに生まれた。父親がテキスタイルのビジネスに携わっていたことで、幼いときから布地に対する審美眼を養う。サヴィル・ロウのテーラー「ジョン・マイケル」に5年間勤めた後、独立してヴィンテージ・クロージングを扱い始め、後に自らがデザインしたメンズウェアコレクションを展開し、高い人気を博す。
日本をはじめ、世界各地に店舗を展開するメンズファッション界のリーダーの一人であり、アストンマーティン・レーシングチームなど、英国を代表するスポーツへのパートナーシップでも知られている。

Text & Photographs: Jeremy Hackett

Jeremy Hackett, founder and current chairman of Hackett London, was born in Devizes, Wiltshire (England). The son of a businessman in the textile industry, Hackett grew up around fabric and developed a keen eye for aesthetic quality. After working at renowned Savile Row tailor John Michael for five years, Hackett started his own vintage clothing business and later went on to develop his own popular menswear collection. Now a world leader in men's fashion with locations in Japan and across the globe, Hackett has also made a name for himself through partnerships with some of the United Kingdom's most famous sports teams, including the Aston Martin Racing team.

翻訳・プロデュース：長谷川喜美　はせがわ よしみ

ジャーナリスト。イギリスを中心にヨーロッパの魅力を文化の視点から紹介。メンズファッションに関する記事を雑誌中心とする媒体に執筆。著書に『サヴィル・ロウ』『ビスポーク・スタイル』（万来舎）など。
Gentlemen's Style　www.yoshimihasegawa.tumblr.com/

Translation & Production: Yoshimi Hasegawa

A freelance Japanese journalist who covers the cultural appeal of Europe, and particularly Britain. Recent publications include Savile Row, Bespoke Style (Banraisha Ltd.).
Gentlemen's Style　www.yoshimihasegawa.tumblr.com/

〈初出一覧〉

FIRST APPEARANCES

Being a Gentleman GQ JAPAN NOVEMBER 2012
Watches Vanity Fair

〈写真〉

PHOTO CREDITS

Garda Tang - Cover image and page 163
Nick Tydeman - pages 11, 14-15, 36-37, 63-64, 104-107, 113
Clym Evernden - Page 68, 82
Sam Churchill - 101
All other photographs by Jeremy Hackett

MR CLASSIC
YESTERDAY & TOMORROW
ミスター・クラシック イエスタデイ&トゥモロー

2016年11月19日　初版第1刷発行

著　者：ジェレミー・ハケット
翻訳・プロデュース：長谷川喜美
発行者：藤本敏雄
発行所：有限会社万来舎
　　　　〒102-0072
　　　　東京都千代田区飯田橋 2-1-4 九段セントラルビル 803
　　　　電話　03(5212)4455
　　　　E-Mail letters@banraisha.co.jp

装幀・本文デザイン：引田 大 (H.D.O.)
編集協力：株式会社オフィス宮崎
印刷所：株式会社東京印書館
© Jeremy Hackett, Yoshimi Hasegawa 2016 Printed in Japan

落丁・乱丁本がございましたら、お手数ですが小社宛にお送りください。
送料小社負担にてお取り替えいたします。

本書の全部または一部を無断複写（コピー）することは、
著作権法上の例外を除き、禁じられています。

ISBN978-4-908493-09-6

MORNING AFTER